IMAGES
*of America*

# HENRIETTA

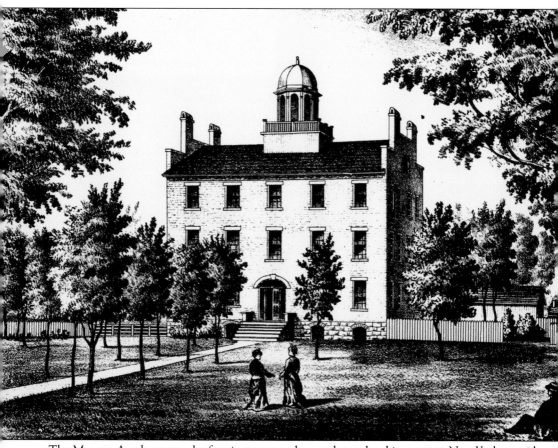

The Monroe Academy was the first incorporated secondary school in western New York, outside of Canandaigua. Built in 1826, it was dedicated to the advancement of higher learning. The Monroe Academy was a boarding school, and its first class consisted of over 250 students who studied the classics. Tuition was $5 for 12 weeks. The school served the community for over 150 years, many of those years as the Henrietta High School. It burned to the ground in 1974.

*On the cover*: Please see page 88. (Courtesy of Gilbert Stone.)

IMAGES
*of America*

# HENRIETTA

Helen Vollmer Elam

ARCADIA
PUBLISHING

Published by Arcadia Publishing
Charleston, South Carolina

Printed in the United States of America

Library of Congress Catalog Card Number: 2006931604

For all general information contact Arcadia Publishing at:
Telephone 843-853-2070
Fax 843-853-0044
E-mail sales@arcadiapublishing.com
For customer service and orders:
Toll-Free 1-888-313-2665

Visit us on the Internet at www.arcadiapublishing.com

This book is dedicated to Eleanor Kalsbeck, the former Henrietta town historian who wrote *Henrietta Heritage*; to all those individuals who help preserve local history; and to longtime resident Mary Hafley Vollmer (on left), the author's grandmother.

# CONTENTS

# ACKNOWLEDGMENTS

The recording of a town's history is usually best accomplished by people who grew up and lived in the community. Without the work and dedication of local historians, the record of small-town America would be lost. Thanks go to everyone at Arcadia Publishing for providing guidance and assistance in the development of the manuscript and for publishing the book.

I would also like to thank the following people for their help and contributions: Gary Goodridge for his technical expertise in the scanning of pictures and Kathleen Englert for her work in searching for materials and in cataloguing photographs.

Thanks also go to the people who proofread the book: my son, James D. Elam, Elizabeth Miller, Margot Naulleau, and Vivian Heffernan, former Henrietta town historian.

I wish to thank especially the many people of Henrietta who so graciously lent me their treasured old pictures and told wonderful stories of their families: John Virgilio for those of Mortimer and Ridgeland, Phyllis Virgilio for photographs of River Meadows and flooding along the Genesee River, John Tirabassi for pictures of his farming operations, Florence Hetrick for pictures of West Henrietta and John Street, Henrietta Public Library local history librarian John Funt for pictures of people and buildings, and Glen Gifford for postcards.

I am very grateful to Selden Chase, Jane Tally, Mr. and Mrs. McCauley, Phyllis McHargue, Ron Symond, Bobbi Gardner, Alta Doty, Susan Halpin, Betty Halpin, Gilbert Stone, Nancy Churnetski, Richard Meisenzahl, Raymond Feasel Jr., and Dave Oliver for sharing pictures of their ancestral homes, farms, and the town.

*Henrietta Heritage*, by Eleanor Kalsbeck, and *The Role of Local History*, by James C. Olson, were valuable resources.

My thanks go to Supervisor James R. Breese for his direction and support and, finally, to James W. Elam, my husband, for his suggestions, love, and patience during this time of preparation.

# INTRODUCTION

Arcadia Publishing's Images of America series offers the opportunity to tell the stories of towns in pictures and words. The history of these communities is significant to understanding the larger American history. The Latin phrase *e pluribus unum*, "one out of many," can be said to apply to hamlets, villages, towns, and cities. Following is a developing American history of one such place, Henrietta, from 1800 to 1940.

The history began with the sale of land by Native Americans to Oliver Phelps and Nathaniel Gorham that is known as the Phelps and Gorham Purchase. This purchase was the most important real estate transaction of its day, because it opened western New York State for development after the Revolutionary War. It encompassed over a million acres, starting north from Lake Ontario, south to the Pennsylvania border, east to Geneva and west to the Genesee River. First included in the town of Northfield (which after 1808 was called Boyle and then named Pittsford in 1814), Henrietta was called the Woods of West Town, or sometimes just West Town. It is located in township XII, range VII of the Phelps and Gorham Purchase.

When the early settlers were not allowed full representation in Pittsford because their deeds had not been recorded (erroneously), they broke away and formed their own town in 1818. The new name of Henrietta was chosen in honor of Henrietta Laura Pulteney, Countess of Bath, making Henrietta the only town in Monroe County named for a woman. She was the daughter of Sir William Johnstone Pulteney, the Earl of Bath, lawyer, member of parliament, wealthy landowner, and the major investor of the London Associates who bought the Phelps and Gorham Purchase in 1791. The cost was 75,000 pounds or $275,000, amounting to 26¢ an acre. After the London Associates sold their investment to Robert Morris, financier of the Revolutionary War, and James Wadsworth, the new buyers, in turn, sold it to Dr. Willem Six of the Netherlands. After Dr. Six died, his brother, Baron Cornelius Charles Six, inherited the acreage. The pioneers bought their parcels of land that were surveyed in the Phelps and Gorham Purchase from both brothers.

The first settlers in 1790 were Maj. Ezekiel Scott and his wife, Catherine, who purchased 900 acres. When Major Scott became ill in 1800, they sold their property to James Wadsworth and moved away.

In the early 1800s, people of English descent settled on the various crossroads of Henrietta; two of those crossroads became known as the East and West Henrietta Villages. Soon afterward, the pioneers established small businesses, followed by schools, libraries, and churches. When Henrietta officially became a town in 1818, it also became the crossroads of Monroe County, since it was the geographical center of the county. Now it is a core area for business and commerce, culture, and history.

The residents of Henrietta, since its early times, have been interested in education. James Sperry, an early surveyor, was instrumental in promoting the building of a secondary school called the Monroe Academy. Opened in 1826, the school was the first incorporated academy west of Canandaigua. It was a boarding school that served the community for many years that later became the Henrietta High School. Unfortunately the building burned to the ground in 1974.

Antoinette Brown Blackwell was born in Henrietta in 1825 and was educated at the Monroe Academy. After graduating, she taught school there. She became famous as the first ordained woman minister in the United States on September 15, 1853, when she was ordained by the Congregational Church in South Butler. She was active in the abolitionist, temperance, and women's suffrage movements and went on lecture tours with Susan B. Anthony, the noted suffragist. She was married to Samuel Blackwell, and together they raised five daughters. Her two sisters-in-law, Lucy Stone (another noted suffragist) and Elizabeth Blackwell (the first woman doctor in America), became nationally famous also. She was inducted into the National Women's Hall of Fame in Seneca Falls in 1993.

In 1968, another educational institution, the Rochester Institute of Technology, moved from Rochester to Henrietta. Here it established a beautiful, large campus with modern buildings. The National Technical Institute of the Deaf was built on the campus to provide classes and opportunities for hearing-impaired students.

Agriculture was the main occupation in Henrietta, and many farms were developed. Known for its rich soil, the town produced much needed food and grain. After the Erie Canal opened in 1825, farmers could send their crops cheaply by barge to markets in New York City and elsewhere; because of this, the town began to prosper. For over 150 years, it remained an agricultural town.

After World War II, things changed. When returning veterans needed housing for their new families, they looked to the suburbs and Henrietta. A building surge began, and new housing tracts were developed. Henrietta became a boomtown. The population grew from around 3,000 people in the early 1950s to 14,000 people in the 1960s. For many years it was known as "the Township of Friendship," and even though the population had soared, it retained its small-town flavor. Today its population is over 40,000.

When Routes 90 (of the New York State Thruway) and 390 (of the Genesee Expressway) opened, they made businesses in Henrietta easily accessible. As a result, many companies and stores were opened here. A retail venture known as South Town Plaza was built on Jefferson Road in the 1950s. It was the first shopping center in Henrietta and is still operating today. In the 1980s Marketplace Mall opened, drawing many vendors and restaurants to the area.

With all the development in Henrietta, a new, modern town hall was built in 1964, with one wing containing the town library. However, the library soon outgrew its space, and a new, modern library was built and opened in 1978. Next to the Henrietta Town Hall, there is the Henrietta Memorial Park, where the Don Cook Senior Center is located. On the other side are the library and the Henrietta Department of Public Works building, which opened in 2004. There are other parks also, but the largest and best attended is the Tinker Nature Park. It houses the Hanson Nature Center and the Tinker Homestead and Agricultural Museum.

Henrietta has been known for its low taxes due to its commercial tax base, and it continues to attract people and new business. Now an urban center, farmland exists only in the southern part of town. What began as an agricultural town has become a residential and commercial one. However, the Historic Site Committee has established 12 preservation districts, protecting many of the old structures.

Every day, Henrietta lives out its history, in both large and small events. Its residents take pride in the early accomplishments of the pioneers and continue to look forward to further achievements now and in the future. They live by the democratic ideals of the country, which are to "further liberty of expression, equality of opportunity and tolerance of others' needs and opinions." This is what America stands for, and this vision can be seen in Henrietta and in other towns across the country.

# One

# HOW HENRIETTA GOT ITS NAME

After the Revolutionary War, land opened up in western New York State. Oliver Phelps purchased 2.6 million acres from the Native Americans at Buffalo Creek in 1788, and he and his partner, Nathaniel Gorham, intended to sell this land to settlers. (Gorham had served as President of the Continental Congress during the Revolutionary War). However, they were overextended, and sought people to buy what was to be named the Phelps and Gorham Purchase. It was sold to Robert Morris, the financier of the Revolutionary War, who sent Benjamin Franklin's grandson to England, to interest European investors. There he met three English gentlemen, Sir William Johnstone Pulteney, the Earl of Bath, and the major investor, William Hornby, and Patrick Colquhoun, who bought the Phelps and Gorham Purchase in 1791 for $275,000.

The French Revolution brought about an economic depression, and Pulteney looked to sell his property; the person who bought it was James Wadsworth of Geneseo. He, in turn, sold it to Dr. Willem Six, a Dutch nobleman of the Netherlands. When he died in 1811, his brother, Baron Cornelius Charles Six inherited the estate. His American agent then sold the plots of land to the English pioneers who settled here.

When Henrietta broke away from Boyle (soon to be called Pittsford) because its residents' votes were not acknowledged, a new town was formed in 1818. The settlers sought a different name for West Town, as it was called then, and named it for Henrietta Laura Pulteney, the Countess of Bath and the daughter of Sir William Johnstone Pulteney.

Henrietta is known as township XII, range VII of the Phelps and Gorham Purchase, and is bounded on the north by Brighton, the south by Rush, the east by Pittsford and Mendon, and the west by the Genesee River.

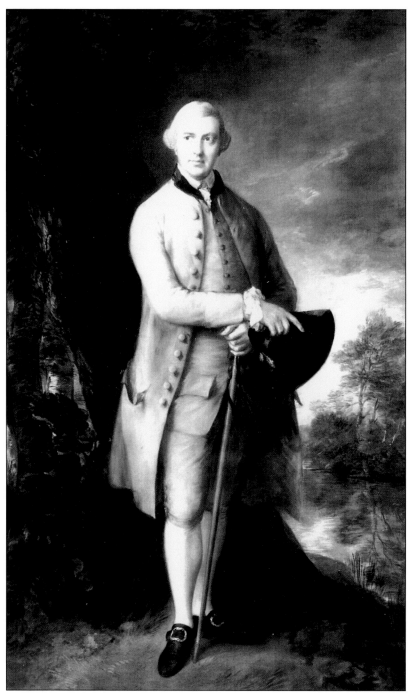

Sir William Johnstone of Scotland, the Earl of Bath, married Frances Pulteney, heiress to Daniel Pulteney's estate, and took the Pulteney name because it was the higher title. As a lawyer, member of parliament, friend of the king, and father of Henrietta Laura Pulteney, William Johnstone Pulteney was one of the wealthiest men in England. When he died in 1805, Henrietta paid the largest estate tax ever levied in Great Britain to that time. This painting is by Thomas Gainsborough (1727–1788) of England. (Courtesy of the Yale Center for British Art, New Haven, Connecticut.)

Henrietta Laura Pulteney (1766–1808) poses for her portrait at about 12 years of age. The artist was Angelica Kauffmann (1741–1807), noted European painter and the only woman founder of the Royal Academy of Art in London. (Courtesy of the Trustees, Holburne Museum of Art, Bath, England.)

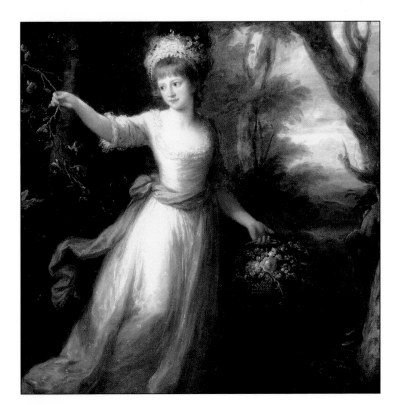

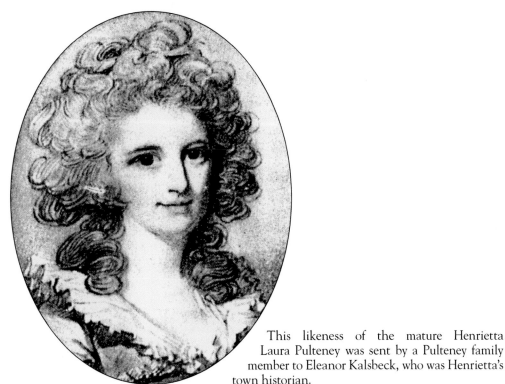

This likeness of the mature Henrietta Laura Pulteney was sent by a Pulteney family member to Eleanor Kalsbeck, who was Henrietta's town historian.

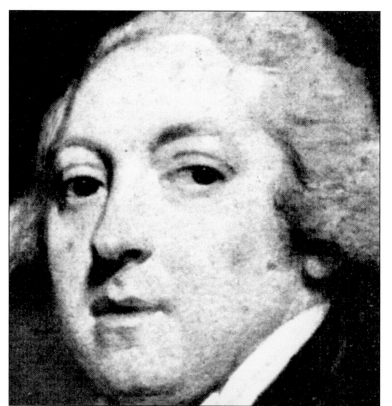

Dr. Willem Six of the Netherlands became the new owner of the Phelps and Gorham Purchase in 1799. This painting is by English artist Charles Howard Hodges (1764–1837).

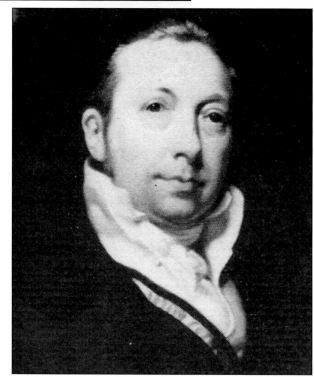

Baron Cornelius Charles Six was the brother of Dr. Willem Six and inheritor of Willem's estate, wealth, and vast lands in America. This painting is by English artist Charles Howard Hodges (1764–1837).

# Two

# East and West Villages

The East and West Villages were settled in the early 1800s, as were other settlements on the crossroads of the town. There were small houses and modest buildings at first, gradually followed by a general store, an inn, a school, and a church. Each building led to the next one.

In the East Village, a general store was built at the intersection of Lehigh Station and East Henrietta Roads in 1823. Of great importance to the village and the town was the building of a new and beautiful brick structure called the Monroe Academy. Less than eight years after the organization of Henrietta, the town fathers promoted the idea to construct a secondary school for the advancement of greater learning. This boarding school was successful and drew students from all over the area. Antoinette Brown Blackwell graduated from the academy and soon afterward, became one of its teachers.

The village grew with new brick houses being constructed from David Deming's brickyard on Lehigh Station Road. A hotel was built, and a church was erected. The village was growing, and Main Street was active with horses and buggies and people. Main Street was later renamed East Henrietta Road, leaving Henrietta without a real main street.

The same development came about in the West Village. The West Village had a road sign that announced the boundary of the village, giving it an identity. That identity led to a rivalry between the two villages.

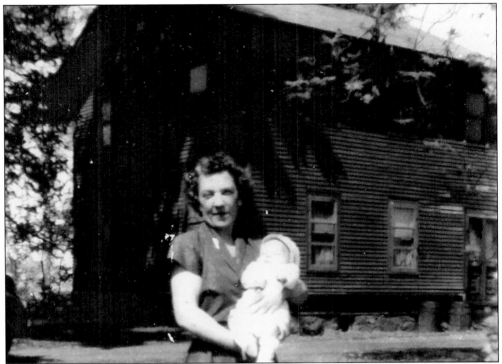

This home was an important stop on the Underground Railroad. It belonged to David Richardson, affectionately known in the village as "Uncle Dave." Richardson would put up slaves in his barn until it was safe for them to escape. Later owners of the building rented it to townspeople. Here Ruth Peterson is shown holding her grandson Harold. The house was demolished to make room for a new housing development.

This orchard setting was on the corner of East Henrietta Road and Calkins Road; it was also a pasture for cows. Today the CVS Pharmacy is situated there.

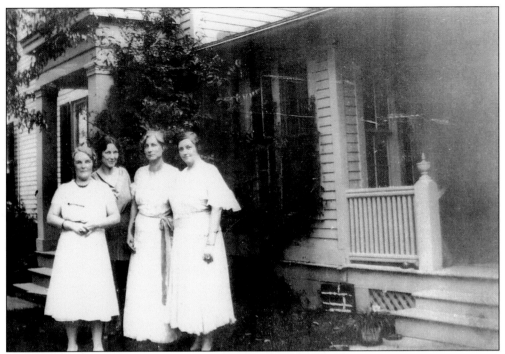

This was the homestead of the Griffin family. Pictured are Gladys Griffin Mundt, Gladys Partridge, Florence Buyck, and Kathryn Stone. The house was later demolished.

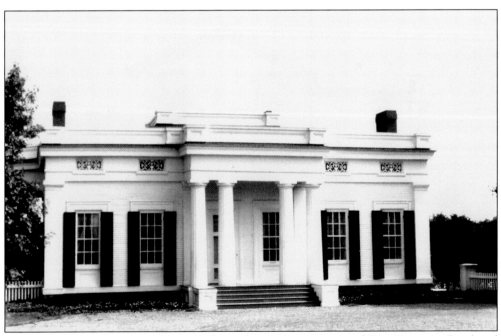

The beautiful Greek Revival house built on the southeast corner of East Henrietta Road and Lehigh Station Road was moved to Stoney Clover Lane in Pittsford in the 1960s. It was the scene of many parties and gatherings when Elihu Kirby, an early Henrietta shopkeeper, lived there.

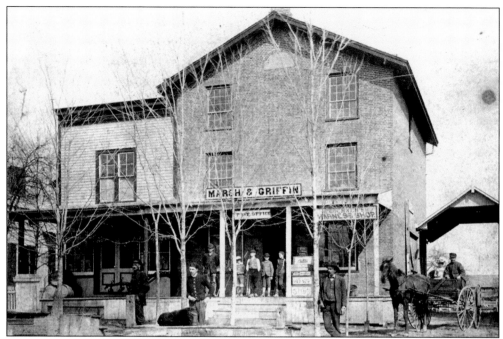

Benjamin Baldwin built the brick structure on the southeast side of East Henrietta Road at Lehigh Station Road in 1824–1825. After Baldwin died, Elihu Kirby purchased the building in 1828. There were many other owners before T. O. Jones bought it and operated it as a general store, selling dry goods, produce, groceries, and Wedgewood crockery (known as cream ware). Fred and Floyd Feasel helped him run it.

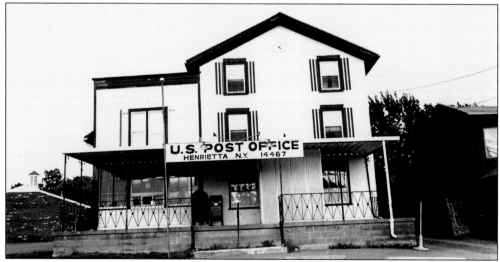

This same building at 3118 East Henrietta Road had a succession of owners. A ? Marsh and Morris Griffin purchased the store, with the Feasel brothers operating it. In 1945, Robert Norget purchased it and modernized it into a self-serve "superette." In 1948, the building was sold to Edward and Mary Nowack, who, by 1961, had remodeled it into an ice-cream parlor. In 1971, the U.S. Post Office rented it, moving from a smaller building next door. Then it became Abiscano Restaurant, followed by Blue Sunday, a coffee house and used bookstore, followed by the Paradigm Café. In recent times, the building has been unoccupied.

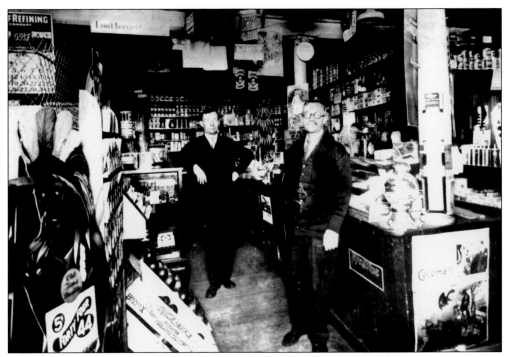

This is the general store as it looked when Fred and Floyd Feasel operated it.

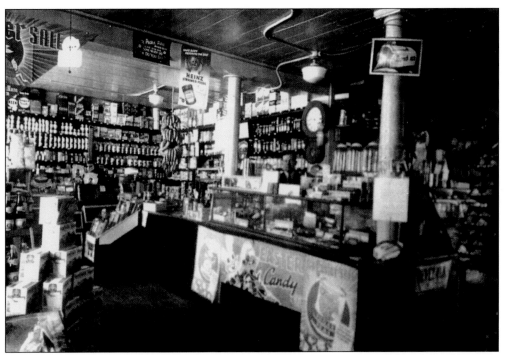

Shown here is another view of the general store when the Feasel brothers ran it.

The small brick building at 3180 East Henrietta Road was known as the Chapin Block. By 1890, Mr. Dates ran a shoe and harness repair shop upstairs, and Betsey Secor rented a room downstairs for the Loyal Temperance Legion. W. Edward Fretts operated a meat market there for years, delivering meat through Henrietta, Rush, and Rochester. The building was torn down when it was determined to be unsafe.

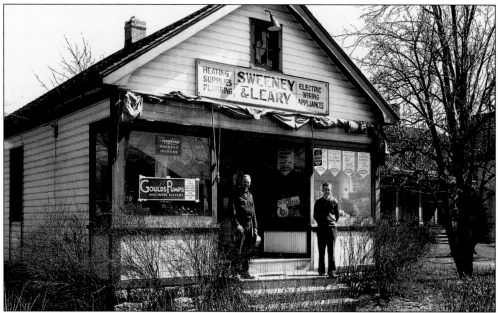

Harry Wood constructed a one-story building next door, at 3170 East Henrietta Road. He operated a meat market there. James Sweeney purchased the building in 1935, where he and George Leary operated a plumbing and heating supply business for many years. When Leary moved away, Sweeney operated the business alone. In recent times, the building was sold to Tim Borschoff, who rented it to Arlene Oliver as a craft shop.

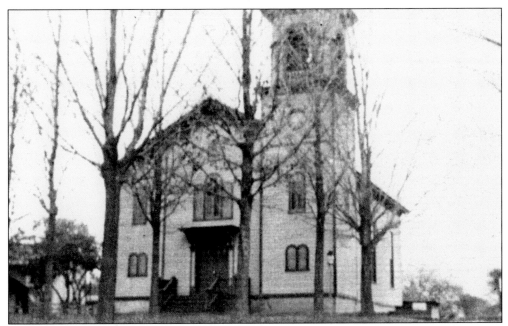

There were several Methodist societies in Henrietta in the early 1800s. One society met and purchased a Baptist church on East Henrietta Road that was condemned and torn down. It erected a frame church on the same site and dedicated the new building on July 19, 1868. Eventually the society dissolved, and the building was sold. George Harrington operated the Henrietta Trading Post there, followed by a farm market. Dr. John Burns, a veterinarian, purchased the building, and in April 2003, he sold it to the Rochester Dog Grooming Institute.

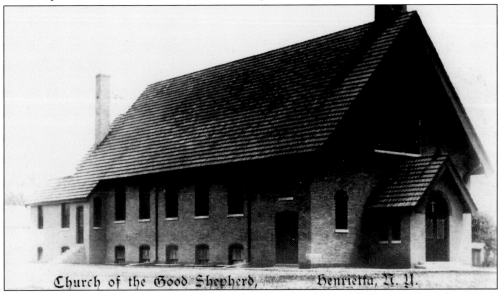

Church of the Good Shepherd,       Henrietta, N. Y.

Good Shepherd church, located at 3318 East Henrietta Road (the old Dikeman farm), has grown over the years since it was dedicated on February 12, 1912. Today the congregation includes more than 1,200 families. A school was built to the rear of the church and opened in 1958; a new addition was added in 1964. Rev. George Vogt was the pastor for many years when the school was expanded. Rev. Douglas Della Pietra is the co-pastoral leader, along with Sue Reed.

This is the Alfred Stone house and barn. The child standing is Susie Stone Cook. Alma Edna Clark and Alfred and Bertie Stone are seated out front. The farm was located approximately where Stonewood Village is now.

The Quaker meetinghouse was built on Calkins Road on land donated by member John Russell. Some 30 families had come from the Rochester meeting and from Mendon to form the Friends community. After a time, the meetings languished and the building was sold to Hiram Calkins, who used it as a barn. Members here went to the Mendon meetinghouse. The old burial ground of the Quakers was to the west of the meetinghouse. Both the meetinghouse and cemetery are now gone.

This brick house at 3045 East Henrietta Road was the Headmaster's House for the Monroe Academy. The school principal lived there and often had students from the school boarding there as well. The house was recently refurbished, and the owners had a real-estate office there until they retired. The offices in it are rented, one to New York State Assemblymen Joseph Errigo.

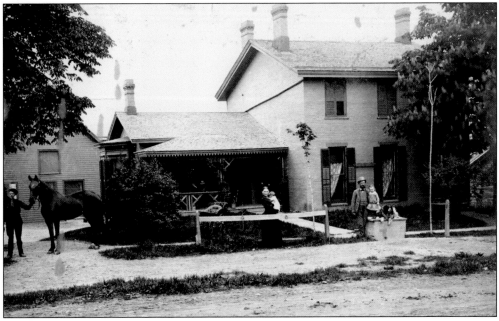

Dr. Daniel Mason stands with his son Floyd, wife Bessie, and baby in front of their house at 3059 East Henrietta Road. The dog's name is Watch. A hired girl sits on a swing on the porch, and a hired man is taking care of the horse.

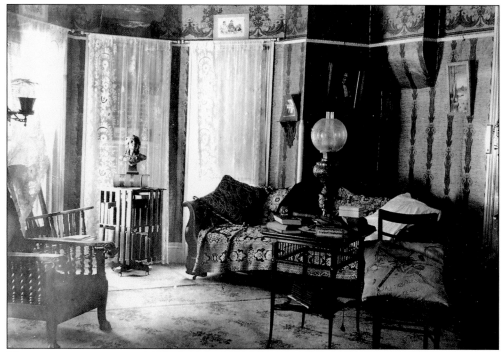

This is an interior room of Dr. Daniel Mason's house at 3059 East Henrietta Road. Note the interesting wallpaper.

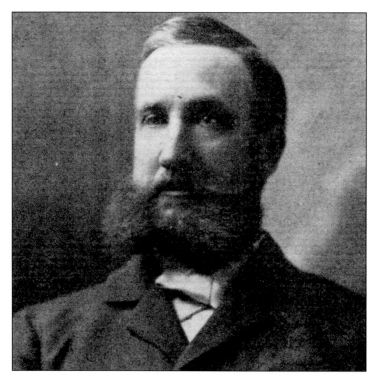

Dr. Mason was an early Henrietta physician.

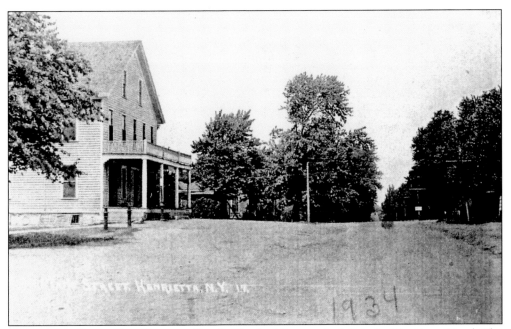

This is Main Street (East Henrietta Road). The building on the left is the Henrietta Hotel. The street is not paved and has only one lane.

Retta Feasel, owner, tends the Suburban Shop on East Henrietta Road.

In this Main Street (East Henrietta Road) picture are three buildings: the large one with cupola has a gas station, the small one-story building in the center held the Suburban Shop at one time, and the free-standing building is the old firehouse.

A gristmill existed on East Henrietta Road near the Timothy Stone farm.

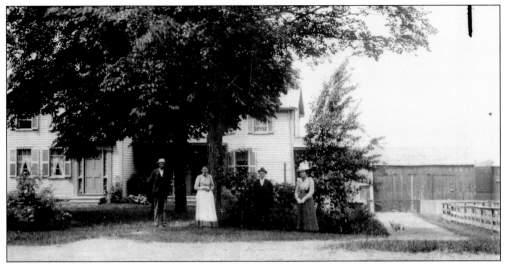

This is the Timothy Stone farmhouse on East Henrietta Road.

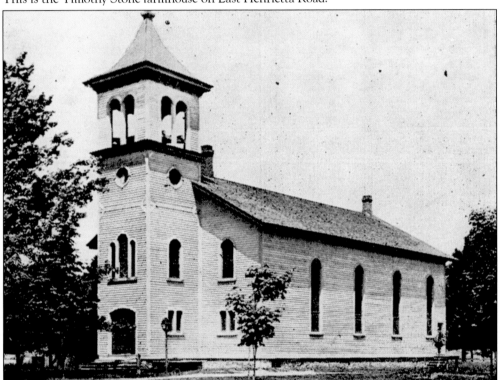

This structure was known as the Congregational church. At a meeting of residents in 1815, the decision was made to form a religious group called the Manville Society. Members built a church in 1832 at 1670 Lehigh Station Road. Frederick Douglass, former slave and internationally known abolitionist, spoke at the East Congregational Church, as it was called in its day. Antoinette Brown Blackwell often preached there. In January 1867, a fire broke out in the church and after it had to be demolished. The next year, a new church was built on the same property. In 1961, the church became affiliated with the United Church of Christ and a new church was built at 1400 Lehigh Station Road. The Congregational church was demolished.

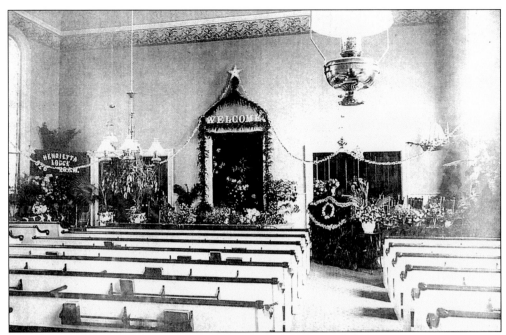
The interior of the Congregational church is pictured in the mid-1800s.

The first religious group in Henrietta was a Baptist society formed in 1812. The society built a frame church on Reeves Road, along with a parsonage and burial ground. A fire broke out in 1871, and the church was damaged beyond repair. The congregation built a new church on the same spot and dedicated the building on July 4, 1877. The church is still standing, and a new Baptist congregation holds services there.

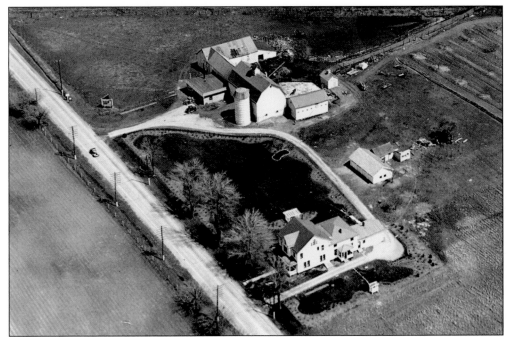

The West Village has many interesting buildings. An aerial photograph shows the house and barns of the Meisenzahl Dairy located on West Henrietta Road. It had a store where milk, cheese, and other dairy products were sold. Its most popular item was ice cream. Many a person remembers, as a child, buying an ice-cream cone at the dairy and then going across the street to Lollypop Farm to see the animals.

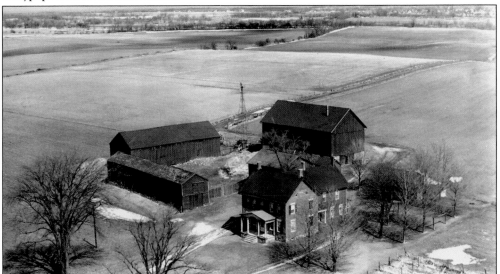

South of Methodist Hill was the McNall farm at 5000 West Henrietta Road. The house was built by Joseph Williams, an early blacksmith. The McNalls were early pioneers. A descendant, Trudy McNall, became a television personality, hosting a cooking show on television channel 8 for 15 years and then giving cooking demonstrations across the United States for the R. T. French Company. This picture of the McNall house and barns was taken before the New York Thruway broke up the farm. The house was demolished in the 1990s.

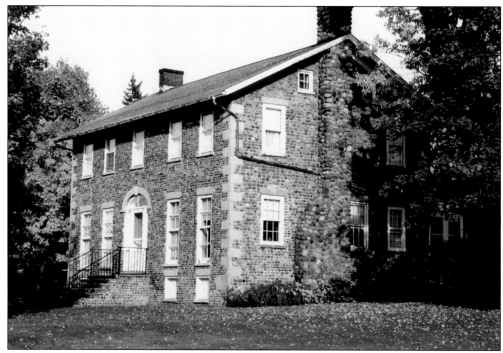

The cobblestone house at 5582 West Henrietta Road is known as the Abel Post home. Abel Post was an early pioneer. It is believed, but not officially documented, that the house was a stop on the Underground Railroad. A business firm called the Horizon Group purchased it in 2003 and refurbished it into a showcase building.

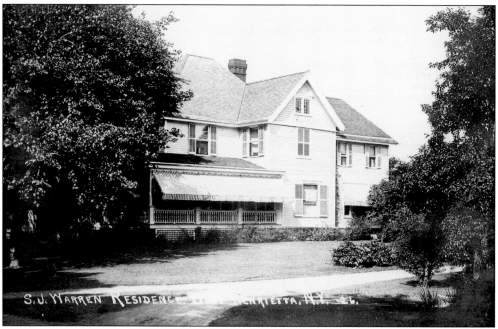

This big frame house on West Henrietta Road was once the home of S. J. Warren, a noted Henrietta resident. Its current owners are restoring the house to its former beauty.

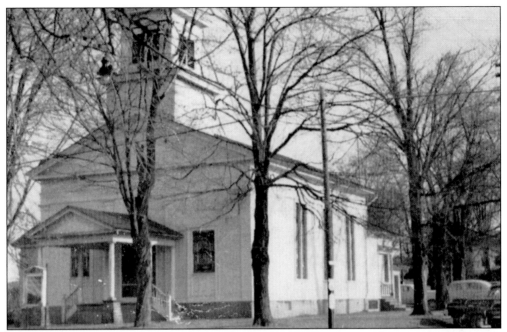

A second Baptist society was formed in 1815, calling itself West Baptist Church of Pittsford. This was before the town was named Henrietta in 1818. At that time, the congregation renamed the church the West Henrietta Baptist Church. In 1838, the members built a new church at the northeast corner of West Henrietta and Erie Station Roads. The congregation still meets and has as its pastor Rev. David Hess.

This hotel was built in 1821 and was operated by Henry Chapman at 5694 West Henrietta Road. Upstairs there was a spring floor for dancing. A fiddler's seat was located in the upper hallway. After the hotel closed, the building served as a private residence until it was demolished in 2005.

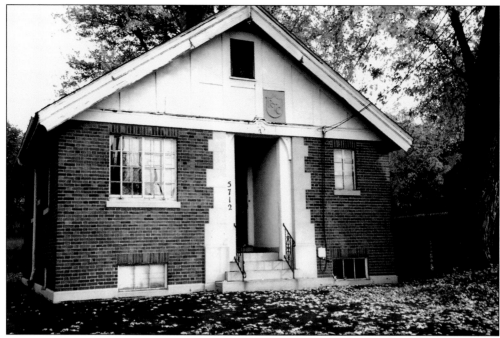

The next little brick building, at 5712 West Henrietta Road, housed the Rochester Telephone Company. Now it is a private residence.

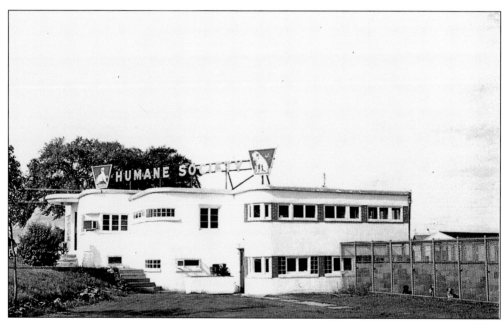

The Humane Society, directed by Raymond Naramore, was located in this building on West Henrietta Road. The Humane Society is now in Perinton.

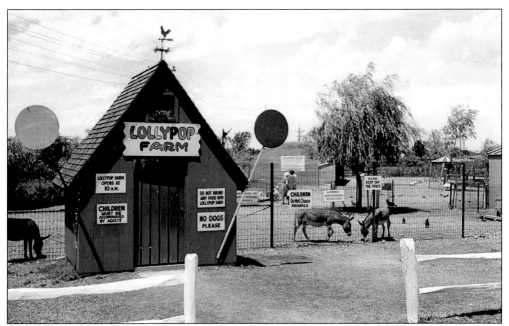

Lollypop Farm was the name given to an area dedicated to live animals who roamed the property of the Humane Society. Children loved to enter the area and feed the animals, who would follow them around.

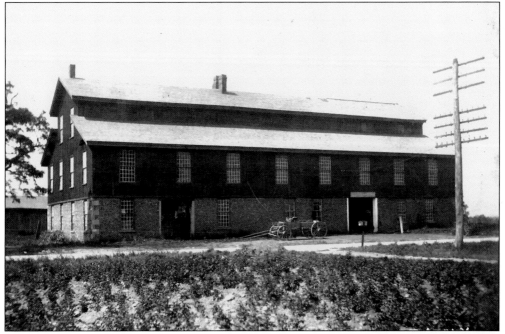

The cobblestone building known as the Carriage Shop at one time had over 50 employees working there. In addition to making wagons and carriages, it was also a blacksmith shop. Later it became the Smith Garage. A very popular restaurant called the Carriage Stop was there for many years, followed by other restaurants. A devastating fire occurred in the 1980s, and the third floor was demolished. Now the building has become the Moose Lodge Family Center.

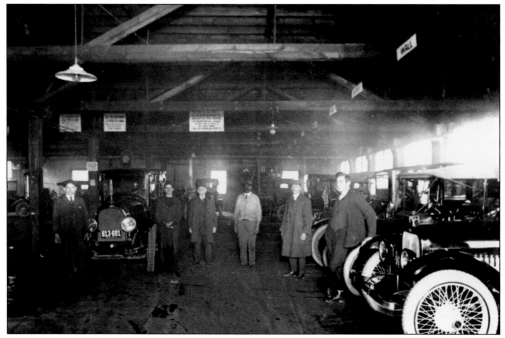

This 1917 photograph shows the Carriage Shop when the building was a garage, with many cars waiting in line to be fixed.

Three girls wait patiently outside the Smith Garage. They are Ruth and Inez Maurer and a girl named Leah.

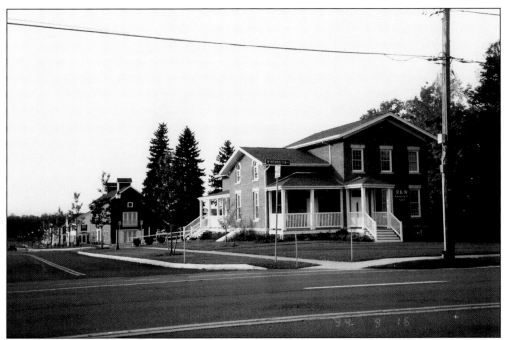

The brick building on West Henrietta Road was purchased by Emidio Tirabassi, who had immigrated from Sodoma, Italy, in 1917, settling first on Middle Road. Tirabassi brought up his four children in the brick building, and when he died, his son Frank took it over. In 2003, Konar Properties bought the house and the Tirabassi farm behind it. The house has been restored as a showcase home.

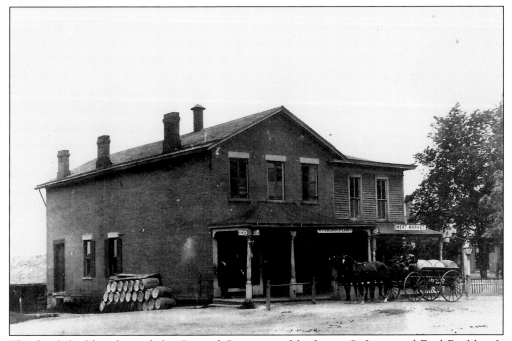

This brick building housed the General Store owned by James C. Jones and Fred Buckley. It burned to the ground in 1905.

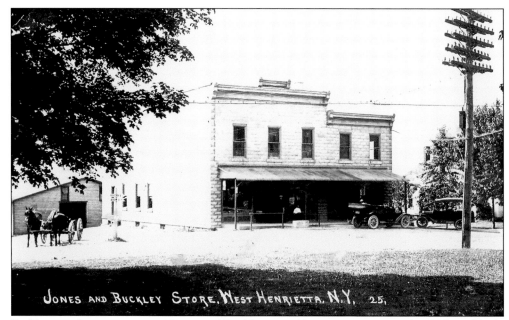

JONES AND BUCKLEY STORE, WEST HENRIETTA, N.Y. 25,

Building on the same property, Jones and Buckley erected a new structure made of Edison block, a new material whose developers claimed was fireproof and would last forever. In 1919, Howard and Earl Chase bought the building, and by 1921, Howard owned it alone. He operated the general store, adding a meat market and soda fountain. A rear room contained the Rochester Telephone Company, where several operators were employed and where the first telephone in Henrietta was installed. When the telephone company left, Howard installed a poolroom. At various times, this same area contained a bakery, barbershop, beauty parlor, and realtor's office. Now the building is owned by Selden and David Chase.

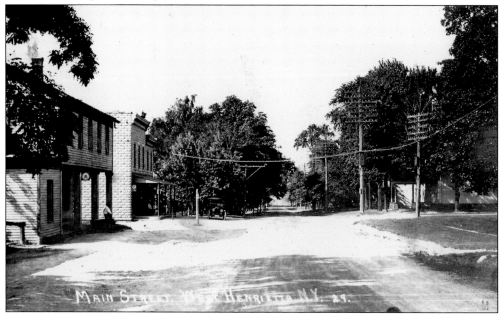

MAIN STREET, WEST HENRIETTA, N.Y. 29.

A postcard of Main Street in the West Village shows the Cartwright Inn and the Corner Store on the left. Across the street is the West Henrietta Baptist Church.

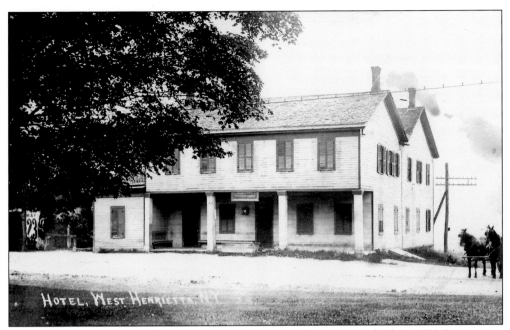

Another postcard shows the hotel, which was a stagecoach stop. It was built in 1830. Later it was called the Cartwright Inn and Restaurant and was famous for its clam chowder.

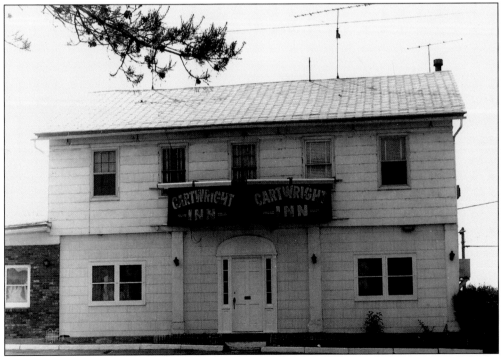

This is another view of the Cartwright Inn, it has been refurbished since this image was taken.

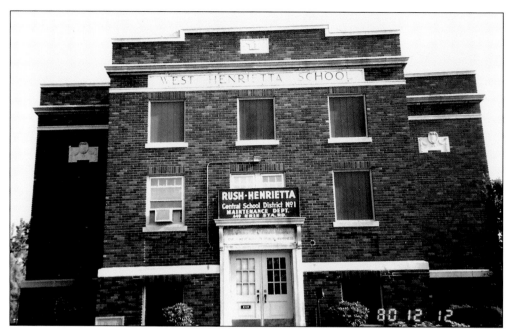

At one time, this school building was used as the Henrietta Town Hall. The Rush-Henrietta School District later took back the building, which it now uses for school offices.

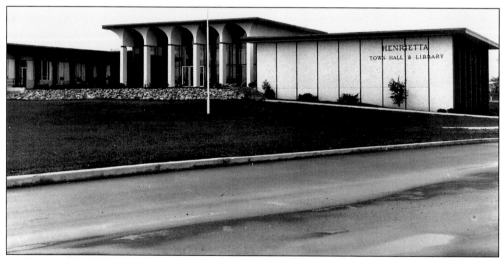

In 1964, this building was dedicated as the new Henrietta Town Hall and Library. Town offices were located in the left wing, and the public library was in the right. In a short time, the library had outgrown its premises, and a new library was built in 1978, across from the town hall.

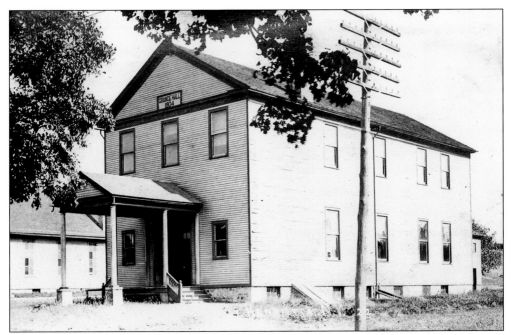

This structure was built in 1904 and became the Henrietta Grange. It remained that for many years, but was eventually sold to the Masons.

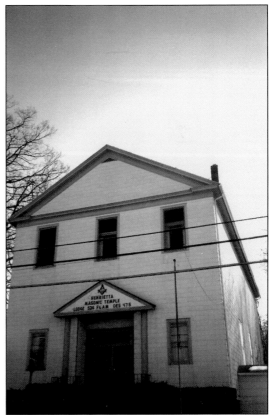

The Masons of Henrietta Lodge No. 526 bought this building in 1959 and renovated it as a Masonic temple. The building was dedicated on October 24, 1961. In the 1990s, it was sold to Maurice Stewart. At this time, it is rented to the Henrietta Church of the First Born, an African American church.

The members of St. Mark's Lutheran Church took over this church building in 1904, when they had their dedication. In 2004, they celebrated 100 years, with appropriate festivities. The pastor is Rev. Larry Gerdes.

This building was owned by the West Henrietta Baptist Church, which used it as a parsonage. Later the building was sold to St. Mark's Lutheran Church, next door, which also used it as a parsonage. Now it is a private residence.

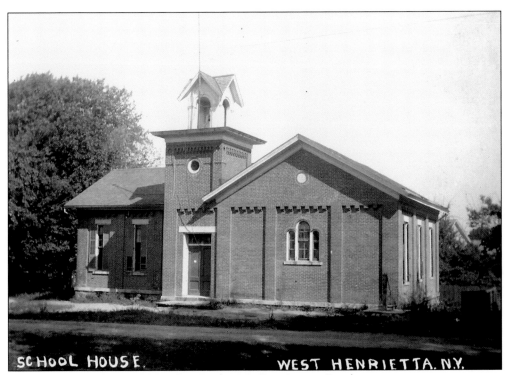

This is the No. 8 District School, located at 774 Erie Station Road.

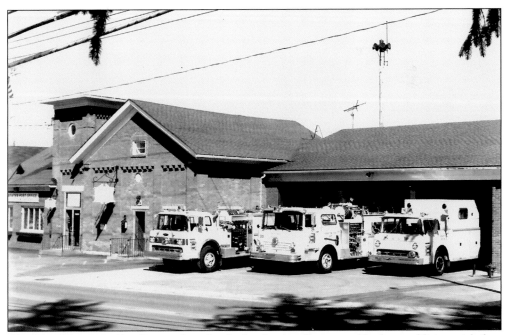

The West Henrietta Fire District bought the brick schoolhouse and built an addition with four bays for the fire trucks.

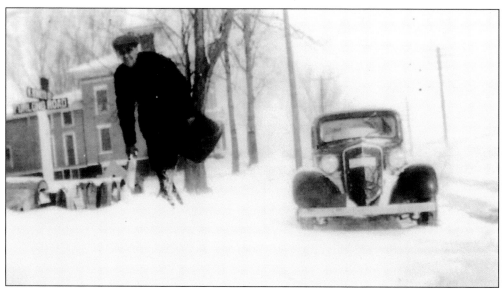

Raymond J. Feasel Sr. makes the rounds of his rural postal delivery for the United States Post Office. Despite snow, hail, and sleet, he got the mail out. He was the first rural delivery postman for Henrietta and Rush.

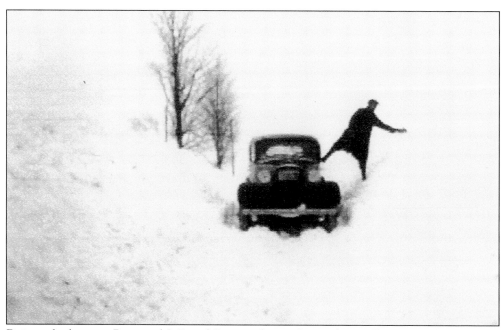

Doing a high jump, Raymond J. Feasel Sr. gets the mail into the mailbox. His job must have agreed with him, as he lived to be 103 years old.

# Three

# EARLY SCHOOLS, MONROE ACADEMY, AND ANTOINETTE BROWN BLACKWELL

After the early settlers built their homes, their next thoughts turned to the building of schools for the education of their children.

The first schools were made of logs and they each had a fireplace. It was difficult, however, to heat the entire room. Fuel for the fireplaces came from the parents, who were expected to supply a cord of wood for each child they had enrolled in the school. Parents were also expected to board the teacher for a full month for each of their children attending the school.

By 1843, there were only five log schoolhouses remaining in the county.

The Monroe Academy was built in 1826 on East Henrietta Road. At that time, it was the only incorporated secondary school located west of Canandaigua. A boarding school, the first year more than 250 students attended who were taught the classics. In later years, it became the Henrietta High School. Unfortunately it burned to the ground in 1974. Many prominent people were educated there, among them Antoinette Brown Blackwell, who graduated from the school and then taught there.

Antoinette Brown was born in Henrietta in 1825 in a log home on a farm on Pinnacle Road. From those early beginnings, she went on to national fame as the first ordained woman minister in the United States. She attended Oberlin College, graduating from the theology course, but was refused a license to preach because she was a woman. However, she was ordained by a Congregational church in South Butler on September 5, 1853. She married Sam Blackwell and they raised five daughters.

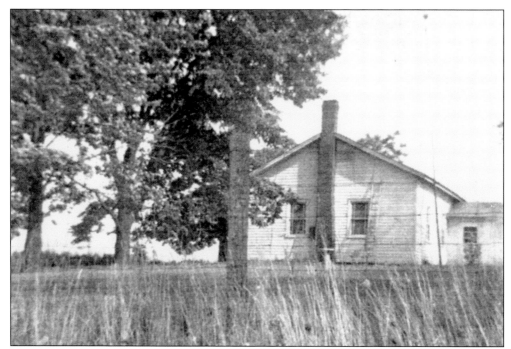

District No. 1 School was located at 72 Pinnacle Road. The building is still standing and is a private residence.

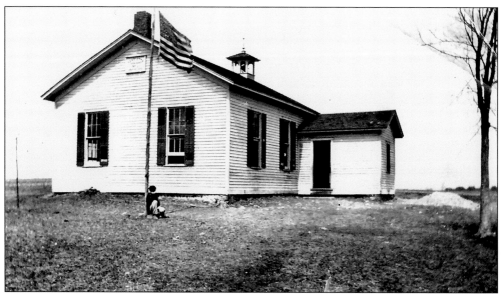

This is a picture of District No. 2 School. It is on the northwest corner of Pinnacle Road and Lehigh Station Road. Built in 1875, the building is still standing and is a private residence.

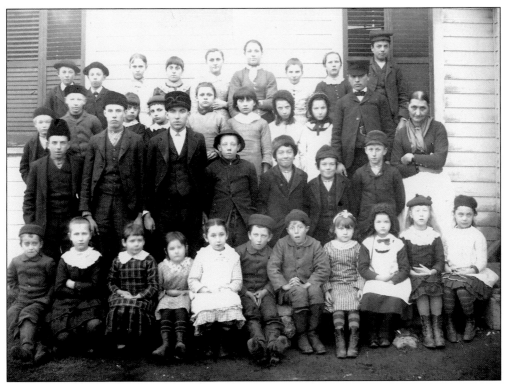

Posing for their picture are students from District No. 1 School .

This picture is of District No. 2 School. It is located on the north-west corner of Lehigh Station Road and Pinnacle Road.

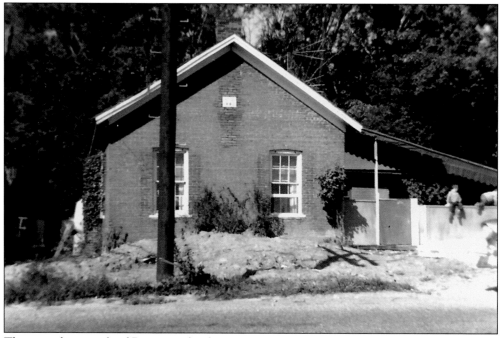

This is a photograph of District School No. 6 on East Henrietta Road near the old reservoir. This brick building was recently restored and is a private residence.

This is a 1923 photograph of students from District School No. 6.

Pictured are students of District School No. 9, located on East River Road near Bailey Road. The teacher is Edna Y. Ward.

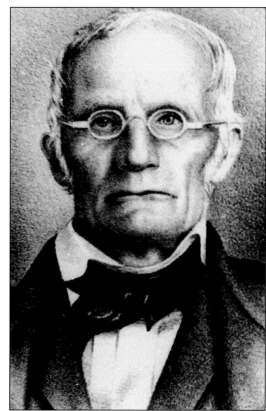

James Sperry, early pioneer and surveyor (who surveyed much of Wadsworth's holdings), was noted for his involvement in the community. He was elected town supervisor in 1825. He also served on the subscription committee for the Monroe Academy. Others who served were L. C. Chamberlain, hotel keeper; Squire Joseph Brown, justice of the peace; and Richard Daniels.

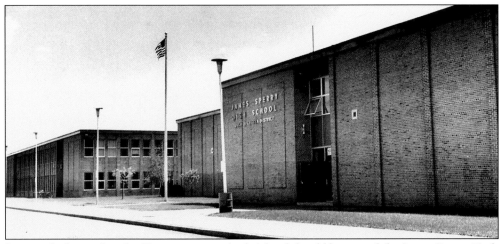

It was only fitting that the Henrietta senior high school should be named the James Sperry High School. Sperry was a man dedicated to educating youth.

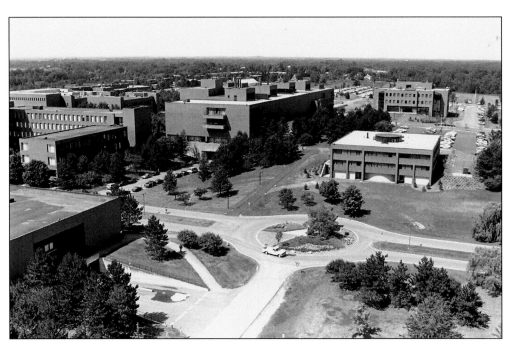

The Rochester Institute of Technology was built on Jefferson Road in 1968. Its beautiful, large campus also houses the National Technical Institute for the Deaf.

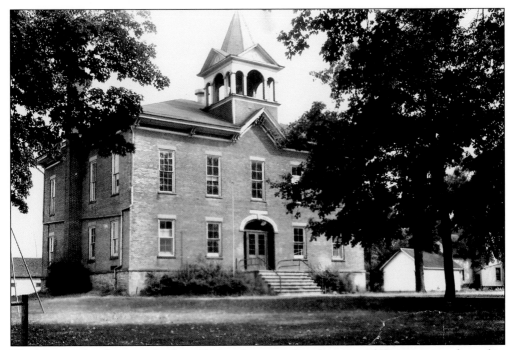

The Monroe Academy was built in 1826, eight years after the town of Henrietta was formed in 1818. Pictured earlier with three floors (see page 2), this 1936 photograph shows only two floors. After a fire damaged the building, the third floor was eliminated.

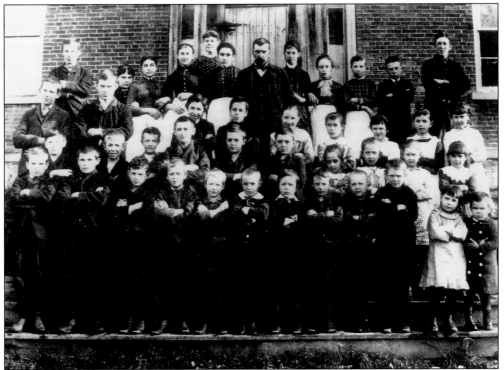

Students of the Monroe Academy pose for a photograph.

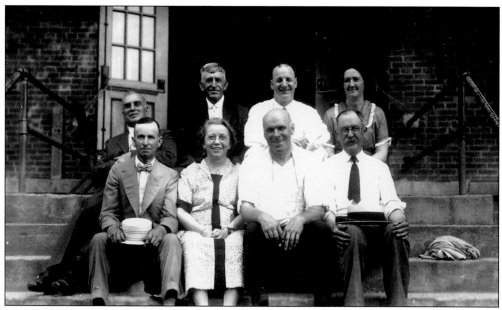

Members of the Centennial Committee of Monroe Academy gather on the steps of the school.

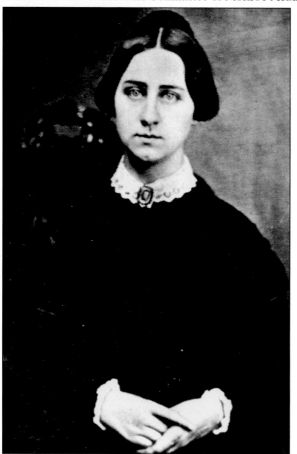

Antoinette Brown Blackwell was attending Oberlin College (about 1846–1850) when this picture was taken. Oberlin College was the first college in the United States to admit women. Although she successfully completed the theology course, the college refused to give her the license to preach because she was a woman. In her later years, she was presented with an honorary Doctor of Divinity degree from Oberlin. She became famous when she was ordained in the Congregational church in South Butler in 1853, making her the first ordained woman minister in the United States. (Courtesy of the Schlesinger Library, Radcliffe Institute, Cambridge, Massachusetts.)

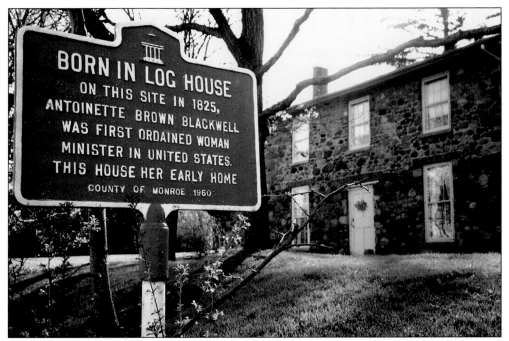

Shown here is Blackwell's childhood home on Pinnacle Road. She was born Antoinette Brown in a log house on this property on May 20, 1825, and moved into this house when it was finished. The house is listed on the National Register of Historic Places.

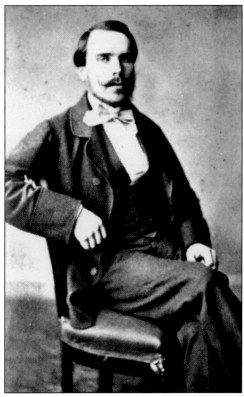

Samuel Blackwell (1823–1901), a successful businessman, married Antoinette Brown in January 1856. They two were married by her father, Squire Joseph Brown, in the front parlor of the Brown home. The groom's brother Henry Blackwell had married Antoinette's best friend, suffragist Lucy Stone, and his one sister, Elizabeth Blackwell, became the first woman doctor in the United States. (Courtesy of the Schlesinger Library, Radcliffe Institute, Cambridge, Massachusetts.)

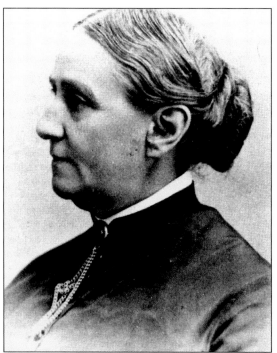

Pictured around 1880, Reverend Blackwell was active her entire life in preaching; in writing seven books; in working for the temperance, abolitionist, and suffrage movements; as well as taking care of her family. She was "a modern woman, challenged by combining family life with career choices, as she continued to write and lecture throughout her life," according to author Mary Britton. The Blackwells established a Unitarian society near their home in Elizabeth, New Jersey. She became pastor emeritus of the society and preached regularly until she was no longer physically able. She always considered herself to be a minister of God's word. (Courtesy of the Schlesinger Library, Radcliffe Institute, Cambridge, Massachusetts.)

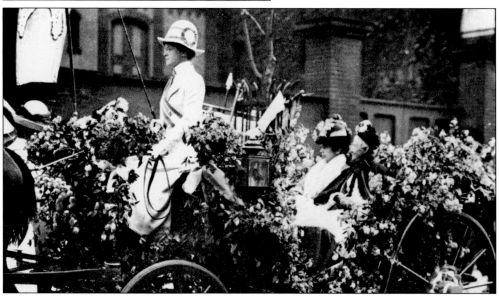

Reverend Blackwell rides with her niece Alice Stone Blackwell (daughter of Henry Blackwell and Lucy Stone) in a decorated carriage at a 1910 suffrage parade. She was active in the suffrage movement from the time she met Lucy Stone, representing its leadership on different occasions, writing about it, and speaking about women's future in America and the world. When the Women's Suffrage Amendment (known affectionately as the Susan B. Anthony Amendment) to the United States Constitution was passed in August 1920, she voted. She was the only one of the original suffragists who was alive to do so. At age 95, she voted for Warren G. Harding for president. She died the next year. She was inducted into the National Women's Hall of Fame in Seneca Falls in 1993. (Courtesy of the Schlesinger Library, Radcliffe Institute, Cambridge, Massachusetts.)

# *Four*

# COBBLESTONES
# AND HORSESHOES

Cobblestone architecture is a unique form of folk art. This art of the 19th century produced masterpieces that should endure through the next millennium and beyond.

The masons who constructed the buildings took stones that lay in the fields or along the lakeshore and made structures of exceptional strength and beauty. The 13 cobblestone buildings remaining in Henrietta are wonderful examples of their art.

There are more than 700 cobblestone buildings in a radius of 50 miles from the city of Rochester. They were mostly farmhouses, but other structures, such as schools, churches, town halls, and stores, were also built. They are unique to the area, and are treasures to be preserved.

The horseshoes referenced in the title of this chapter are what the farrier dealt with in his blacksmith shop. He shoed both oxen and horses.

Dr. Albert Simone and his wife, Caroline, have lived in this house since he was appointed president of Rochester Institute of Technology. The house has had a transformation, with the addition of a wing that is used for conferences and meetings, and the completion of a new apartment upstairs where the Simones have their home. The downstairs is used for public gatherings for the college. Dr. Frank Lovejoy, the previous owner, donated the property across the road to Hillside Children's Center and gave the property on the south side of Lehigh Station Road, which included this cobblestone house and some wonderful barns, to Rochester Institute of Technology.

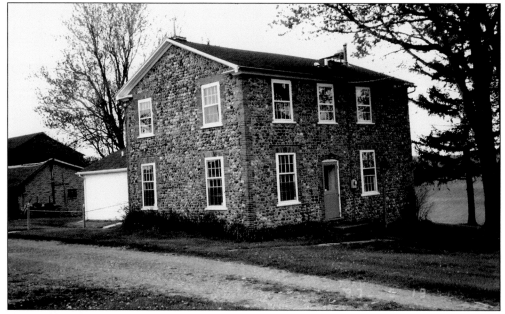

This cobblestone house is a primitive one built about 1828 at 255 Tobin Road. Instead of limestone quoins, red bricks were used, making the house stand out. Originally built by a Mr. Matthews, the house was restored by Donald Weber.

This is the Matthews house, which sits on the top of a hill on Tobin Road surrounded by potato fields and cornfields.

This is the doorway of the John Halpin house. John Halpin was a farmer who also sold farm equipment at his John Deere dealership in Henrietta. The house is of Greek-Revival style. It was built by Rev. Calvin Brainard, on the top of Methodist Hill, a name resulting from the services held there until a church was built.

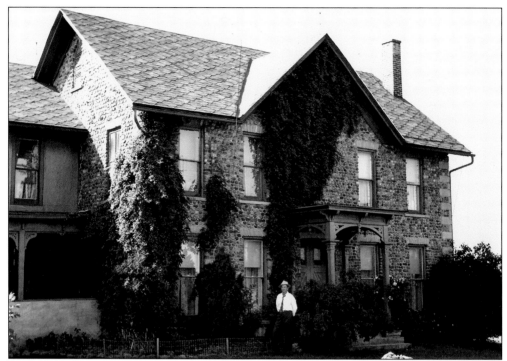

Andrew Bushman settled on Telephone Road in 1811 and built his cobblestone house. It is said that he built a cobblestone house for each of his five sons. This may be true, as there are three such houses on Telephone Road and two more on the Rush-Henrietta Town Line Road, adjacent to Telephone Road. Pictured here is his descendant Leland Bushman.

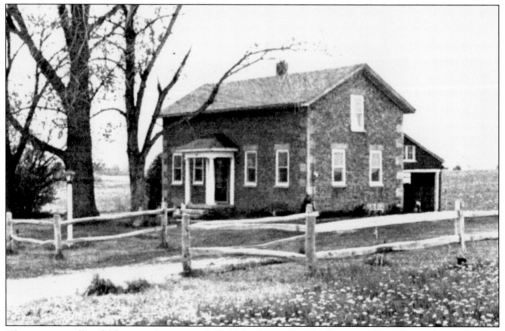

This is a small cobblestone house at 887 Telephone Road that was thought to have been a Bushman house.

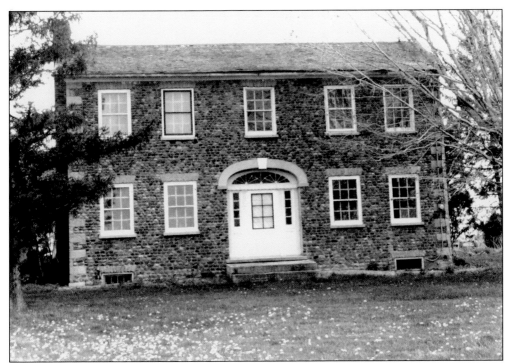

Another cobblestone house was built at 830 Telephone Road. The original owner was a Bushman, but the Gruschow family lived there for many years. It has an exceptional Greek-Revival doorway.

Among the early settlers on the East River Road were John Brininstool and his wife, Susannah, who came in 1810. They built a cobblestone house near Erie Station Road. When Susannah came to her new house, she scratched her name and the date on a bedroom window. The Brininstools are buried in a cemetery on this road that bears their name.

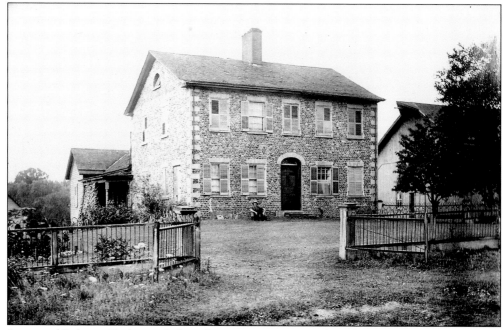

James and Rebecca Tinker settled on this property in 1812, when the street was named Jackson Road. They lived in two log houses with their eight children. Six generations of Tinkers have lived there. The house has five fireplaces with original fittings. The mason of this house at 1585 Calkins Road was Michael McCanty. The house is listed on the National Register of Historic Places. The photograph dates from 1912.

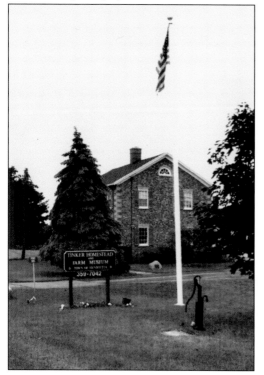

Today the Tinker house is known as the Tinker Homestead and Farm Museum, part of the Tinker Nature Park. In the early 1990s, Carol Tinker Aldridge and John Aldridge donated 65 acres to the town, which in turn bought the house and its contents and developed a park that consists of the Hanson Nature Center with trails through the woods and by a pond. Thousands of people visit the park each year.

Philip Kazmayer ran a blacksmith shop on West Henrietta Road in 1915. He is pictured wearing the typical leather apron of a smithy and carrying a heavy mallet.

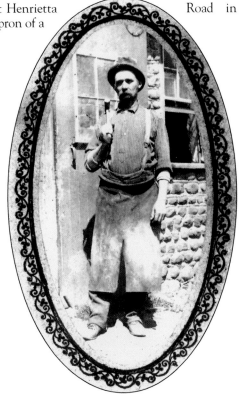

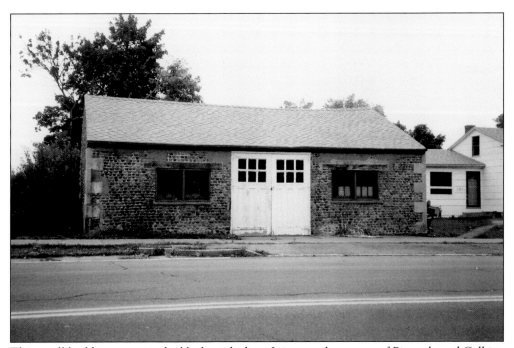

This small building contained a blacksmith shop. It is near the corner of Pinnacle and Calkins Roads, known as Stevens Corners, and is used for storage today.

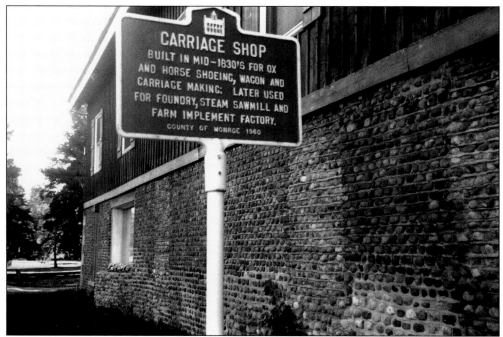

A historic marker identifies the place that was once a blacksmith shop and carriage factory. The cobblestone building, which came to be known as the Carriage Shop, was built at 5393 West Henrietta Road in 1830 by brothers Alexander and Joseph Williams. The brothers were successful and at one time had over 50 employees.

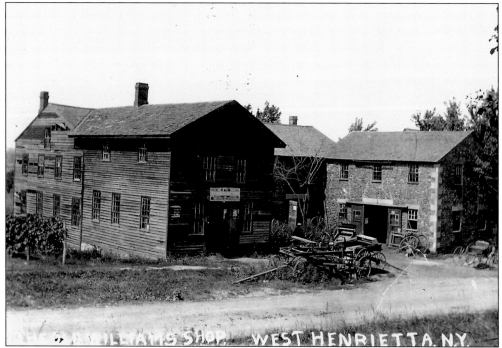

Alexander Williams left his interest in the Carriage Shop and built his own shop south of Erie Station Road on West Henrietta Road in 1835. This, too, was a cobblestone building. It is now gone.

# Five

# MORTIMER
# AND THE RAILROADS

Mortimer was a thriving community in its day, due to the railroads. It encompassed the area on Brighton-Henrietta Town Line Road, west to Jefferson, West Henrietta Road, and East River Road. It also encompassed a portion of West Brighton.

There were many farms in this area, a post office that used the cancellation "Mortimer, NY," and a depot called the Mortimer Stop, built in 1885. The depot was an important stop on the New York Central West Shore Railroads. Passengers would come from Henrietta, along with farmers sending their wares to markets.

In those early days, there was much flooding in spring, when the river overflowed its banks, yet the railroad continued to run.

The farms disappeared in the wake of the commercial and residential building boom, and the depot is gone—most people today have never heard of it. However, Mortimer remains on early maps of both Henrietta and West Brighton, as well as in the hearts and minds of railroad enthusiasts and historians.

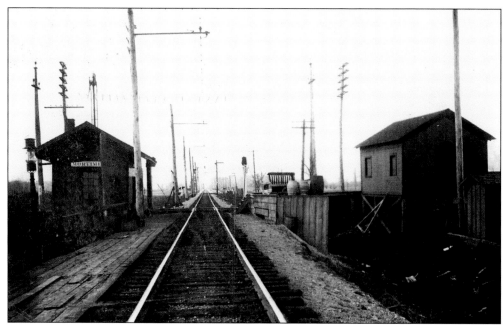

Pictured in 1885 is Mortimer Station, with the Erie, New York Central, West Shore, and Buffalo Railroad tracks.

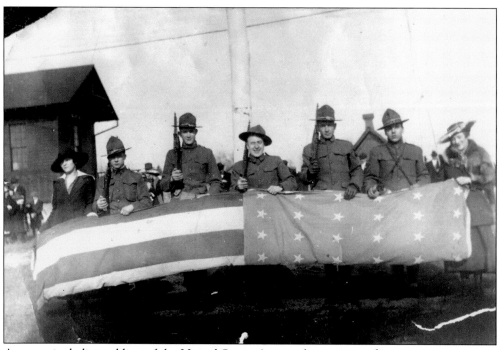

A group, including soldiers of the United States Army, takes part in a flag-raising ceremony at Mortimer Junction on April 28, 1917.

The flag flies proudly above Mortimer Junction in 1917, during World War I.

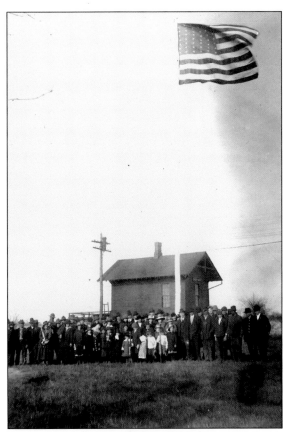

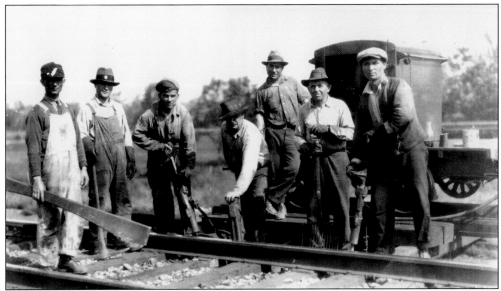

A railroad-track repair crew works on the West Shore line, near Genesee Junction in Chili in 1926. These men also worked at Mortimer and Ridgeland Junctions. From left to right are foreman Jim DiRisio, Myron Lathron, John Rapp, Domnic Picarelli, Dan DiGoovanni, Ed Herman, and Frank Lucci.

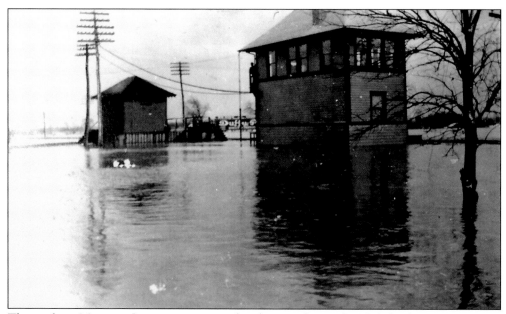

The tracks at Mortimer Junction are covered with water during the 1913 flood.

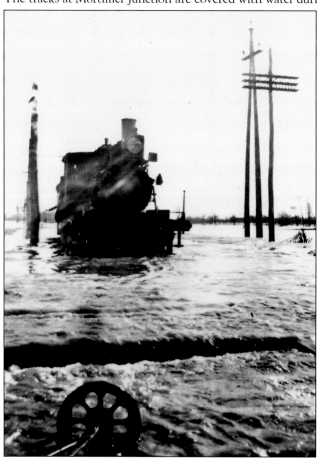

An Erie Railroad train crosses the New York Central tracks at Mortimer Junction. Coming from Avon, the train was trying to make it to Rochester during the 1913 flood.

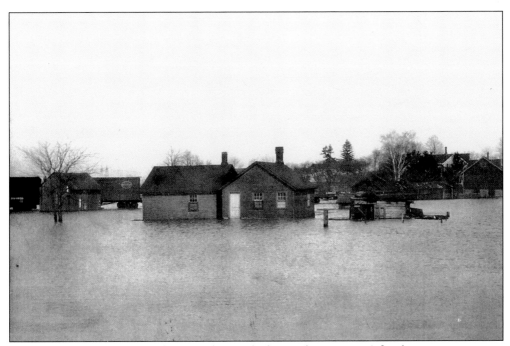

The Mortimer Depot is seen from another angle during the same 1913 flood.

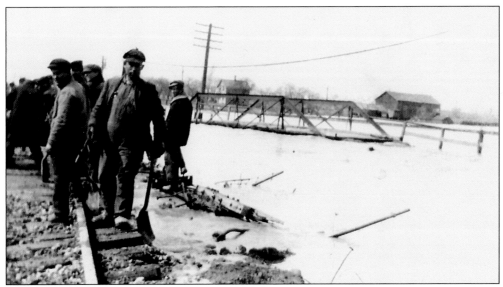

Railroad workers shore up the tracks during the flood of 1913.

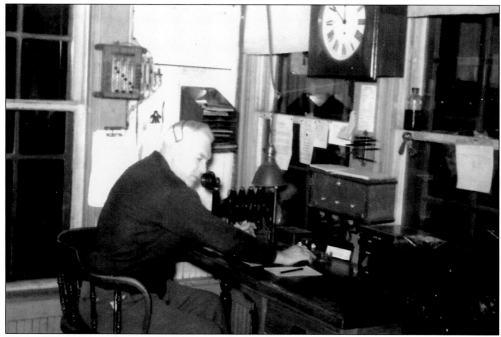

Howard Dunphy works as a telegrapher at the Mortimer Junction.

John Virgilio, historian and railroad enthusiast, stands in front of a locomotive that is located in the front yard of his ancestral farmhouse.

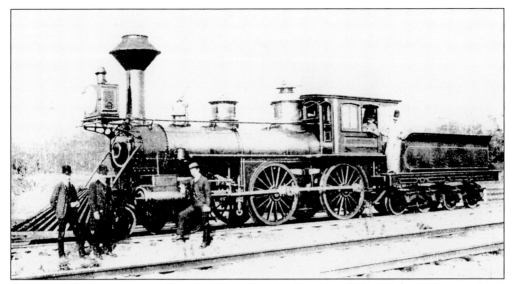

Engines of this type were used on the West Shore Railroad in 1881. In July 1885, an engineer by the name of Webb, running engine No. 45, came from the west out of Buffalo. He made speeds of up to 87 miles per hour. Going through Churchville, Genesee Junction, Red Creek (Mortimer), and Ridgeland, he set a national record.

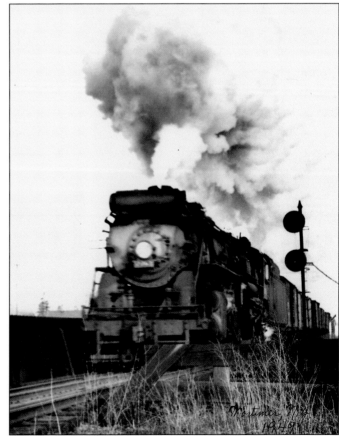

Coming to the end of the steam era, this Mohawk engine 2500 series was moving freight at high speed. The train was coming from the Albany yards. Here it is crossing Red Creek railroad bridge at Brighton-Henrietta Town Line Road, heading toward Buffalo on the New York Central West Shore railroad tracks. This impressive photograph was taken by Henry Dreher in 1949.

Florence Schmiedeke Hetrick poses at Mortimer Junction. She may be waiting for family members to arrive on the next train. The Erie Railroad tracks and Lehigh Valley Depot are in the background.

Fred Meister of Clay Road stands in front of the Lehigh Valley Depot in Rochester. This is where residents got their train ride back home to Henrietta.

Ed Halpin, station agent at Mortimer Junction, shows off his calf in his yard on Brighton-Henrietta Town Line Road. Halpin owned two acres of land that backed up to the New York Central tracks. The white house in the background was owned by the Schmidt family.

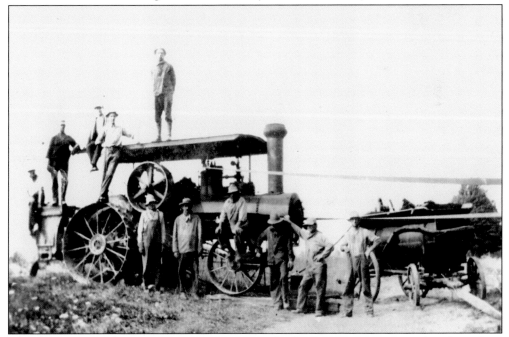

Thrashing, or threshing, was quite an operation for farmers, requiring many hands to do it all. These men are at the Partridge farm on John Street around 1912. John Street was an oxen-and-buggy path in the early days.

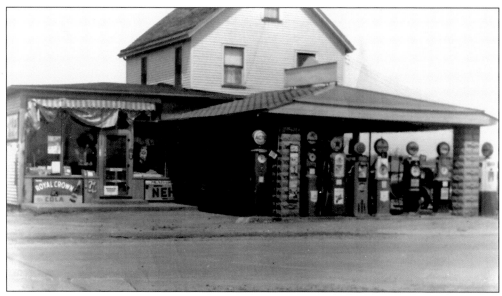

This early gas station was located on West Henrietta Road and Brighton-Henrietta Town Line Road. The building also held the Ramsey and Nix General Store.

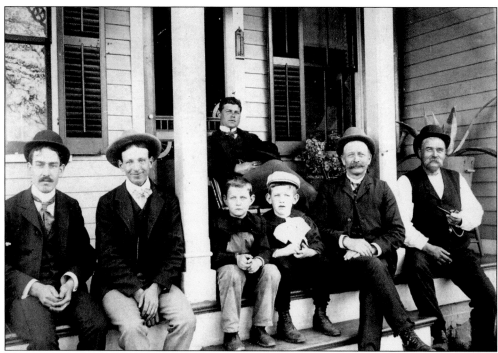

A group gathers on Pete Spaker's side porch to talk about the events of the day in 1898. They may be taking a break from working in the Spaker Cider Mill. From left to right are (first row) two unidentified men, Frank Spaker, John P. Halpin, Nick Spaker, and Peter Spaker Sr.; (second row) Peter Spaker Jr.

## PURE APPLE CIDER

One-tenth of one per cent.
Benzoate of Soda

———

This Sticker must not be used except on P. F. Spaker's Products

This sticker was used on P. F. Spaker's products. The Spaker Cider Mill was quite large, and many people would come to sample the cider.

Plowing snow at the Spaker Farm on Bighton-Henrietta Town Line Road are Art and Charlie Johnson. The vats in the background hold sweet cider.

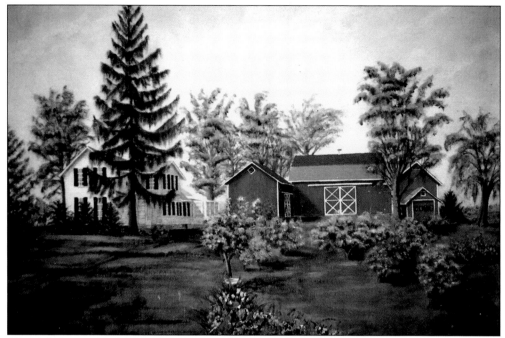

This is the house that John Vollmer built in 1840 on Brighton-Henrietta Town Line Road. Vollmer's grandson Clement John Vollmer, who was born in this house, painted this picture of the farm after the red barn was destroyed by fire. He lost his precious drums in the fire. He married Mary K. Vollmer, the Henrietta teacher for whom the Mary K. Vollmer School was named.

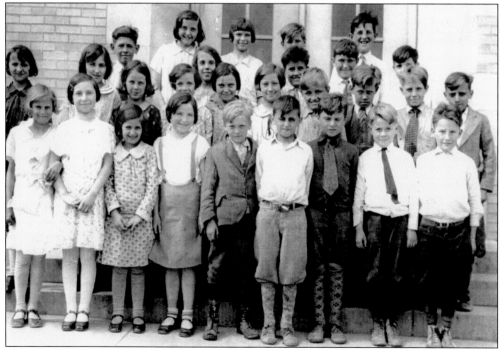

Shown are Mortimer schoolchildren from the Brighton No. 4 School, an overlapping district school that children from Henrietta attended. The picture was taken in the 1930s.

# *Six*

# RIDGELAND AND MORE RAILROADS

Ridgeland got its name from the railroad that runs very close to Brighton-Henrietta Town Line Road. It encompassed the farming area from East Henrietta Road, both east and west, between Jefferson Road and the Erie Canal.

Ridgeland had a railroad depot, a church, the Ridgeland school, a general store, and a blacksmith shop. A long time ago, it was a small but full stop on the West Shore Railroad line, between the Edgewood Avenue flag stop and the Mortimer Station.

The depot, church, school, store, and blacksmith shop are now gone, and Ridgeland is just a memory.

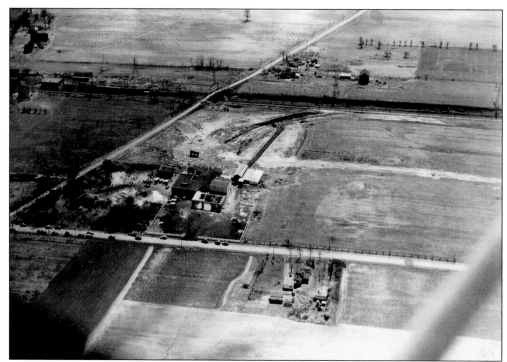

A 1940s aerial photograph of Ridgeland shows the railroad station, the old wooden bridge going over Clay Road, the Samuel Murray log house built in the 1820s, Conti Packing Company with the railroad siding that carried cattle to the packing company, the Conine John Deere sales store, the Legget and Pike farm, and the Miller home and farm.

Pictured are the Ridgeland Railroad Station and the Conine John Deere dealership.

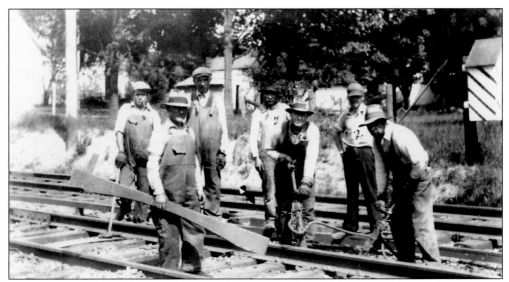

A railroad crew raises track at Ridgeland in the 1920s. Two men are identified: Nick DiVirgilio (fourth from left) and foreman Ed Tannario (second from right).

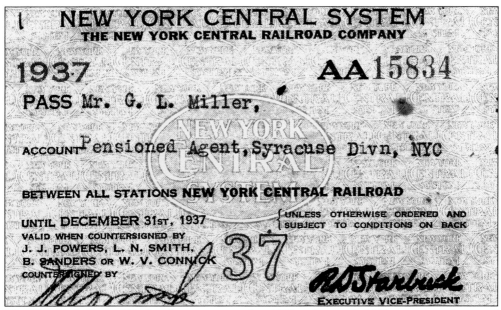

This New York Central Railroad pass was issued in 1937 to George L. Miller, pensioned agent of the railroad's Syracuse Division.

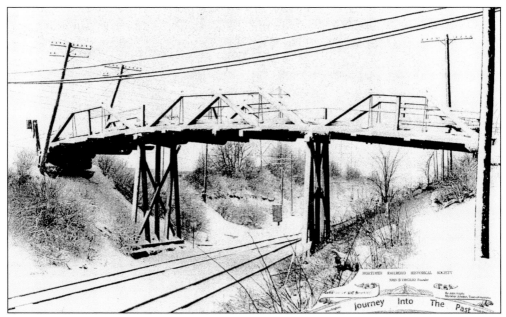

The single-lane, wooden bridge on Clay Road crosses the railroad tracks. Every time someone went over it, the whole bridge would rattle and shake. Finally the bridge was taken down, and a new bridge was built to relieve traffic congestion on East Henrietta Road. The new bridge is not wooden.

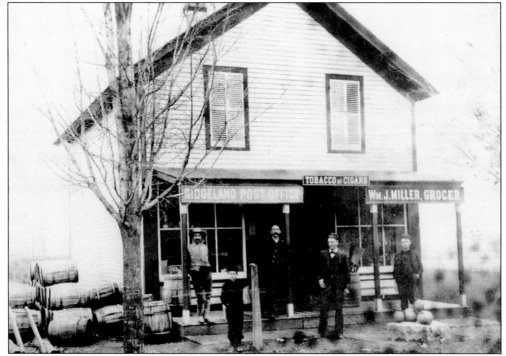

This is the William J. Miller store and post office on East Henrietta Road. William Miller is wearing a bow tie and Joseph Max, a farmer, is leaning against the post. The picture was taken in the 1890s. Later the store became a popular bar. It was demolished in the 1990s.

On his farm in Ridgeland, Bill Brogan holds the reins of two horses that he won in a raffle.

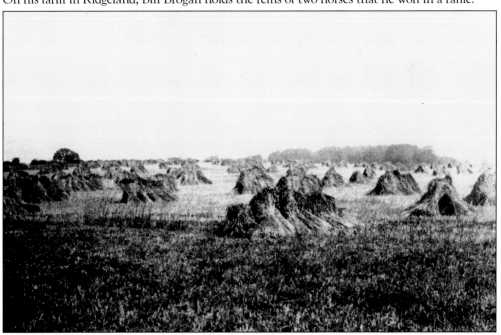

This is a wheat field on Brogan's farm in Ridgeland in July 1915. In those days, Monroe and Livingston Counties were acknowledged as having the best wheat in the United States.

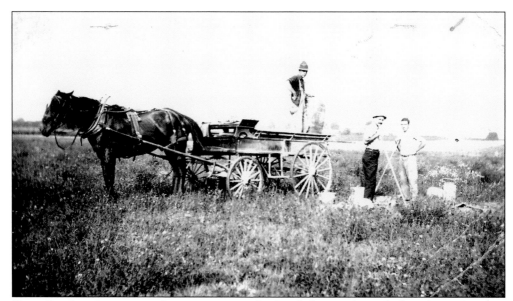

Elmer Smith and sons are picking potatoes on the Smith farm at the end of Brighton-Henrietta Town Line Road. This site is now the plaza called Winton Place.

This is the Henrietta District No. 4 Ridgeland School.

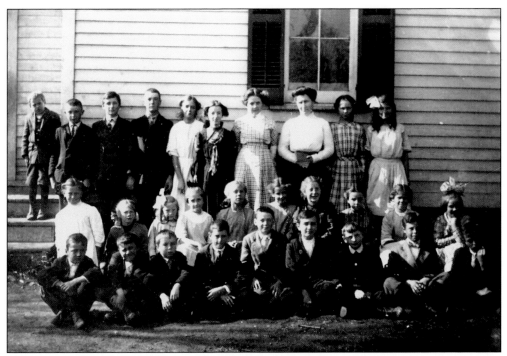

These are students from the District No. 4 Ridgeland School.

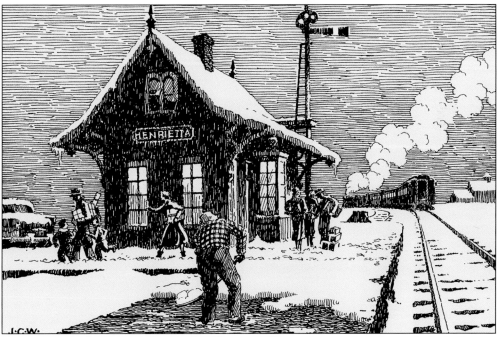

This pen-and-ink drawing depicts the Henrietta Depot that used to be on Lehigh Station Road. It was sketched for a Christmas card by John Wenrich, who lived on East Henrietta Road in Henrietta. An internationally famous artist, Wenrich was best known for his drawings of Rockefeller Center in New York City. His favorite subjects were barns and trains, and many of his train paintings are located at the Landmark Society in Rochester.

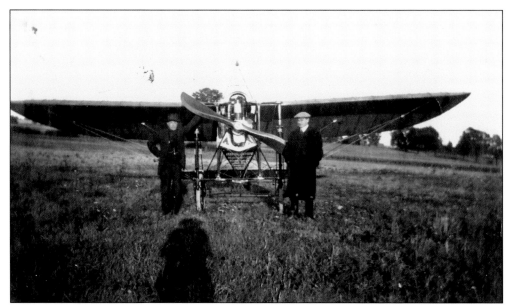

This early airplane was assembled on the French farm in Ridgeland in 1910. It flew over Genesee Valley Park. An airport was located on the corner of East Henrietta and Jefferson Roads in 1938. It was known as the Genesee Valley Airport and was owned and operated by Irving Herman. Later owners, Bert Lewis and Bob Wilson extended the airport to Clay Road. It had closed down by 1947.

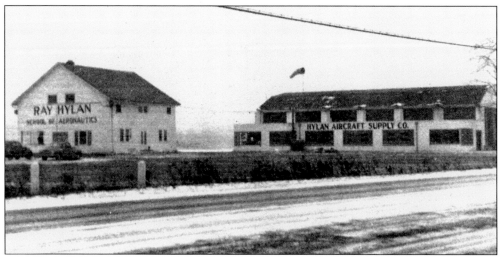

The Hylan School of Aeronautics was located at 3440 West Henrietta Road where Marketplace Mall is situated today. Ray Hylan, a licensed pilot, owned and operated the school. He instructed would-be pilots and arranged chartered trips for individuals. In 1973, he moved his school to an area adjacent to the Rochester airport.

# Seven

# RIVER MEADOWS AND THE GENTLE GENESEE

The first major housing development in Henrietta was called River Meadows. It was built in 1925 along the Genesee River. Some squatter houses already existed there—mostly fishing huts—but now many cottages were built. On Decoration Day (Memorial Day) in 1925, the summer tract opened. Several cottages were being used year-round, and so permanent housing began to be built. The River Meadows Association was formed and brought in street paving, electricity, mail delivery, and other improvements to the area.

Riverview Heights followed in 1928–1938, but most of it was in 1938 after the Depression had lifted. The next housing development took place after World War II. Most of the homes built in River Meadows and River View Heights are still standing.

The Genesee River could be a lovely, gentle waterway, but in the spring or in heavy rains, it could be devastating; its floodwaters could wreak havoc. The worst flood came in 1865. Pictures of downtown Rochester show buildings with water up to the top of the first floor. Henrietta also suffered from the flood of 1913 and another in the 1940s. After that flood, army engineers began to look into building a dam to stop the expensive flooding along the Genesee, and one was eventually built near the town of Mount Morris. It was started in 1948 and completed in 1952. The dam has taken care of the problem to this day.

William Stehler, a U.S. Marine who served in World War I, and his wife Harriet were early residents of River Meadows. This is their house on River Meadow Drive in 1935.

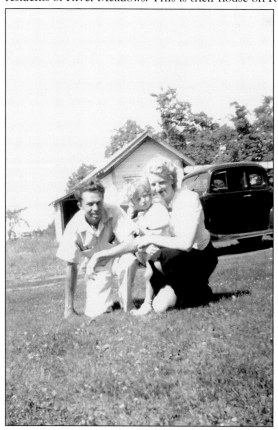

William and Harriet Stehler pose with their daughter Phyllis in 1940.

This house on River Meadow Drive was the home of John and Harriet Nitsch. It is believed that John Nitsch was the first person to spend the winter on that road, where all of the existing homes were cottages. Nitsch, a carpenter and cabinetmaker by profession, put up a small building, installed a stove, and lived there while he constructed his house.

Nitsch had a great love for animals. Putting his skills to work as a carpenter, he made cages and coops for a variety of feathered and four-footed animals. A pony named Duchess and a donkey named Duke were referred to as "the Duke and Duchess of Nitschville."

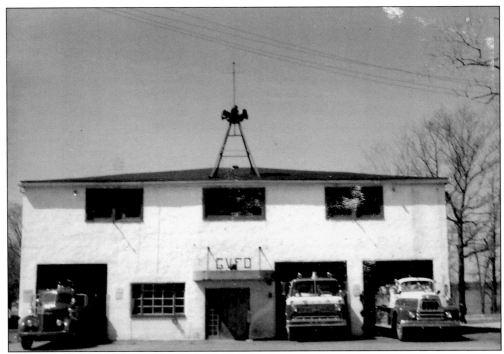

Today this building is the Genesee Valley Firehouse. At one time it was called St. Blaise Chapel, and Good Shepherd Church held mass there to serve the people living in that tract and area.

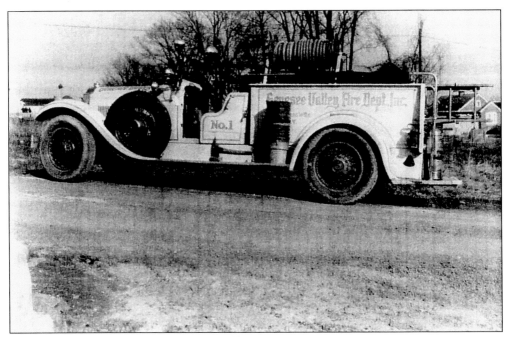

This fire truck belonged to the Genesee Valley District.

Taken from an upstairs window of the Nitsch house, this photograph shows the old Genesee Valley Firehouse is in the background.

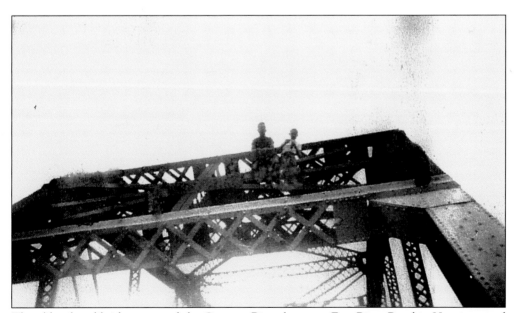

The old railroad bridge spanned the Genesee River between East River Road in Henrietta and Scottsville Road in Chili. As boys will do, Richard and Edwin Holdsworth scoot along the top of the bridge.

Westminster Park was the name given to this popular dance hall and restaurant by the deacons of the old Westminster Church in Rochester when they held a picnic on the grounds. The property at 3821 East River Road was originally the farm of the Quirks, an early pioneer family. Mr. and Mrs. Will Ferguson bought the property and built an ice-cream stand where pleasure boats on the river stopped for picnics. Later they built a room with a dance floor, where local bands played. Then the building was updated and called Elliot's Nest. It has been closed for many years, but it is still remembered as a place for fun since the late 1890s.

Oh, the Gentle Genesee, its waters are calm today and its movement smooth. What a fine time to paddle a canoe downriver to where one can glance at the big city. But, what will happen next spring? Will the river send its waters crashing against the banks and flood the towns and villages along the way? Who knows? For now, one can only float on and dream.

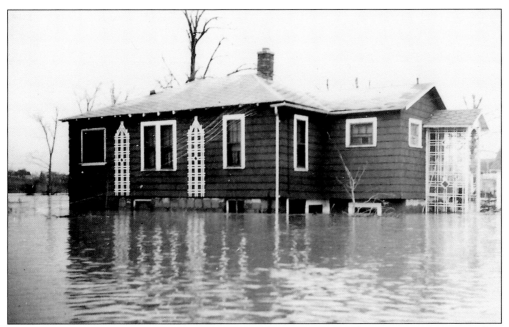

Shown is the home of William and Harriet Stehler during a flood in 1936 on River Meadow Drive. The water flowed at 26,100 cubic feet per second.

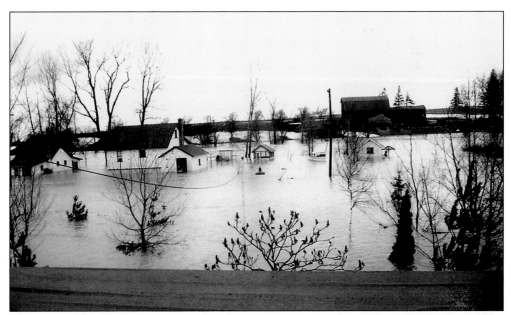

This view of the flood of 1942 was taken from an upstairs window of John Nitsch's house. The water flowed at 32,500 cubic feet per second.

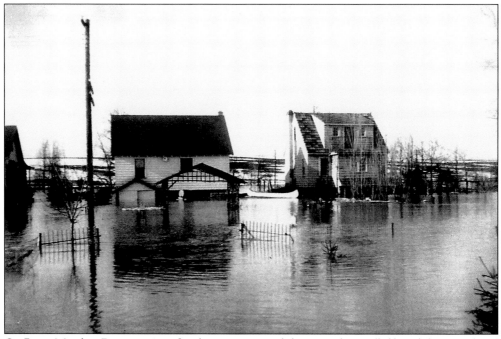

On River Meadow Drive in 1942, floodwaters surround the Amar house (left) and the Mauel and Lisa Enguix house (right).

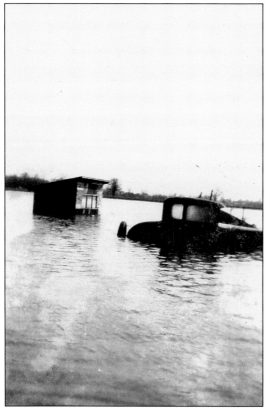

This car is almost submerged in the flood of 1913. In the 1940s, a dam was built south of Henrietta near Mount Morris, saving all the areas north of the dam from drastic flooding. This was a big relief; no longer would there be flooding in Rochester, as in the worst flood of 1865, nor in Henrietta, as in the flood of 1913.

# *Eight*

# SOCIAL GATHERINGS AND RECREATION

In the days before television and other mass media, entertainment was provided by other means. People would gather for family and school reunions and would go to weddings, picnics, outdoor celebrations, and sports events.

Before the advent of the automobile, most activities were held close to home. Afterward people could drive many miles to see ball games or meet with out-of-town relatives.

Pictured in this chapter are activities that people participated in before modern technology took over. Everyone seems to be having a grand time. Thankfully some of these pastimes still take place.

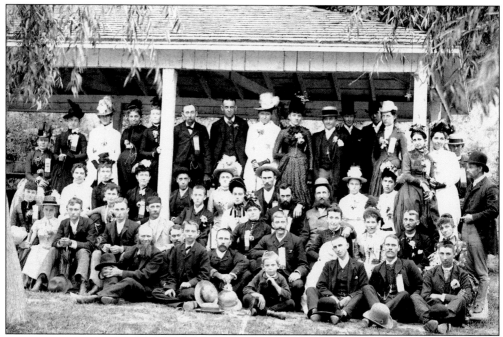

People often gathered for meetings and enjoyed the social aspect of an organization. This scene is from a Temperance Society picnic.

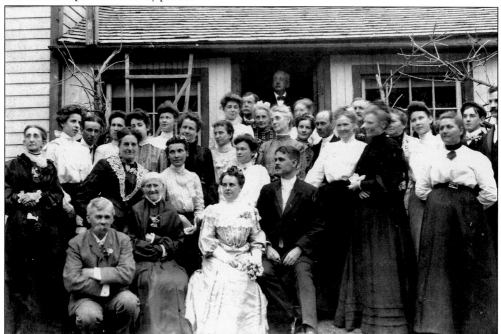

The wedding reception of Susie Stone and Capt. Norman E. Cook took place on May 17, 1904. The bride, a voice teacher at the Powers Building in Rochester, and the groom, an army officer stationed in the Philippines, were married under the old chestnut trees in the front yard of the home of the bride's parents at 3414 East Henrietta Road. They honeymooned in the Philippines. (Courtesy of Gilbert Stone.)

Some 75 people attend the Titus-Jones family reunion. The gathering was held at the Greek-Revival house of the Jones family on East Henrietta and Lehigh Station Roads.

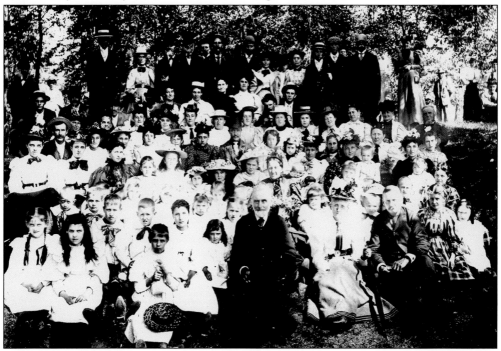

A large group gathers at the school reunion in Ridgeland. Notice the Gibson girl styles of the women in the audience.

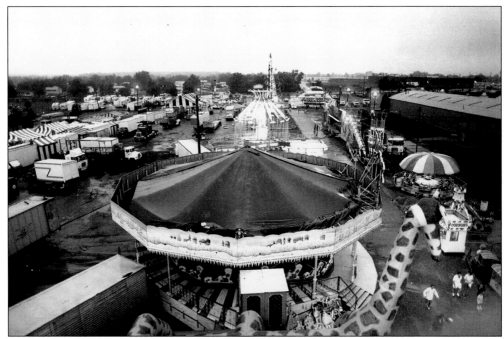

In 1947, the Monroe County Fair Association purchased 60 acres of land in Henrietta at Calkins and East Henrietta Roads. Each year the association held a fair with rides, rabbits and other animals, sideshows, and exhibits of all kinds.

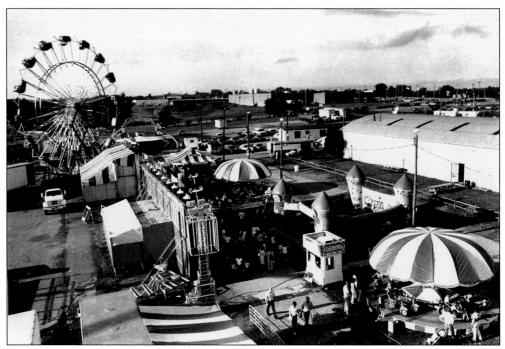

The fair has always been an interesting place to go. This is another view of the fairgrounds.

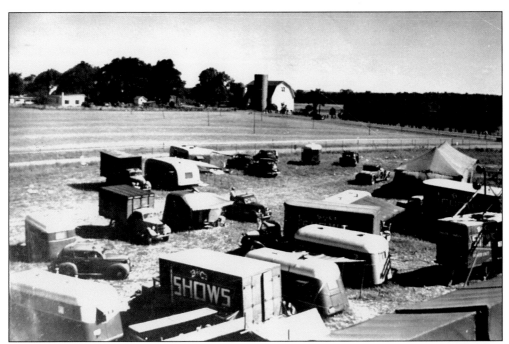

The circus and other shows came to town in vehicles like the ones pictured here. People came from all over to see the circus. The B&C Shows, with their wild animals and daredevil stunts, were very popular.

The Genesee River provided a wonderful spot for recreation and sports. In the winter, people skated on the river. These young women are almost ready to go. First, of course, they must shovel the snow off the ice.

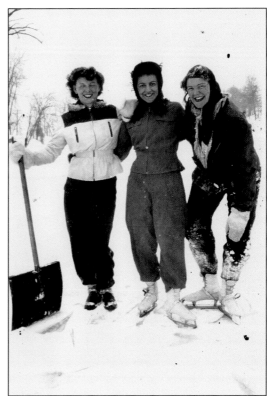

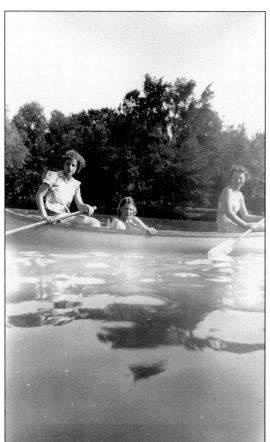

In the summertime, the river became the scene of a lot of boating activity. Here are three young women in a canoe. But where are their life jackets?

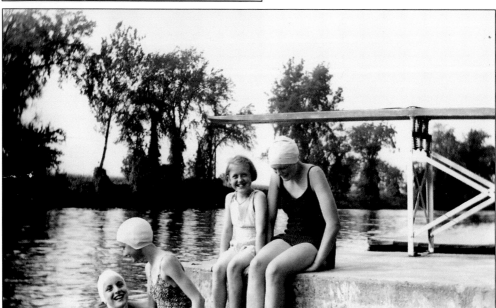

Four children enjoy the cool water of the river on a hot day. Mary Jane Down and Alta Smith Doty sit on the area where the Genesee Valley Fire Department has its dock.

The river also provided nourishment and sport. John Calkins caught this 13-pound fish on a very lucky fishing day. He displays it with pride.

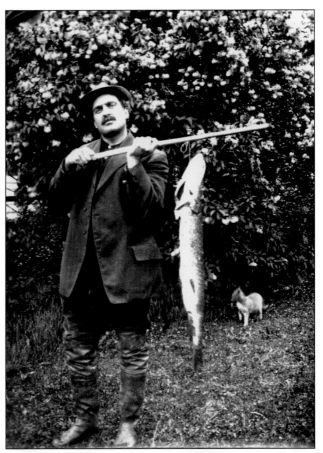

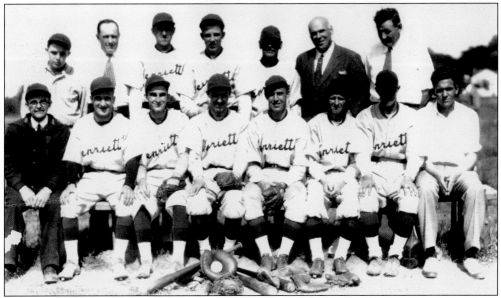

Fred Feasel (first row, far left) is the coach for this team. In their Henrietta uniforms, the players are ready to take on the opposing team.

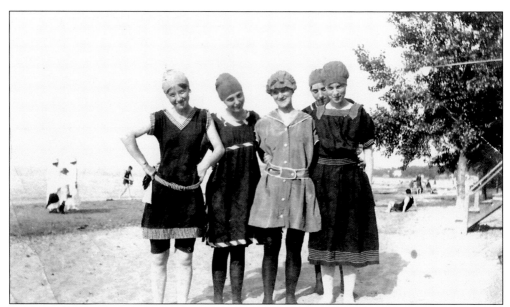

In 1922, a bevy of bathing beauties pose at Conesus Lake. Swimming had to be difficult in those bathing suits. (Permission to use the picture was granted on condition that the names would not be revealed.)

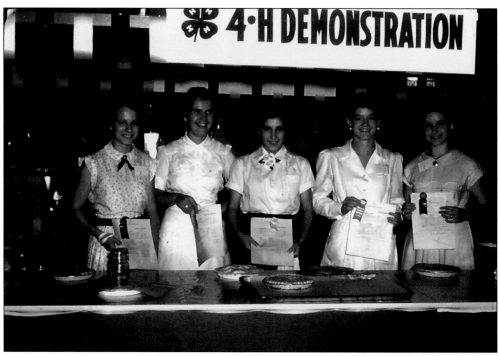

Young Henrietta girls display their fresh-baked pies at a local 4-H demonstration, perhaps at the county fair. They may well have won prizes.

This is a Fourth of July picnic at the Miller farm on East Henrietta Road.

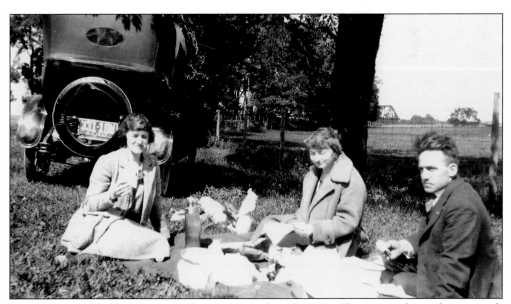

This picnic was held at Seneca Lake on September 17, 1922. This image shows the trio with their new car.

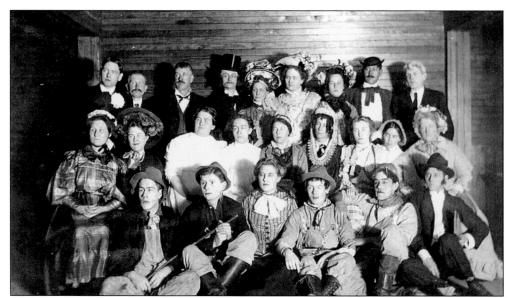

A choir group from the West Henrietta Baptist Church performed in a production called *The Singers Skool* at the Grange hall on January 28, 1909. The group then took the show on the road, performing in East Rush on February 26 and in Scottsville the following week.

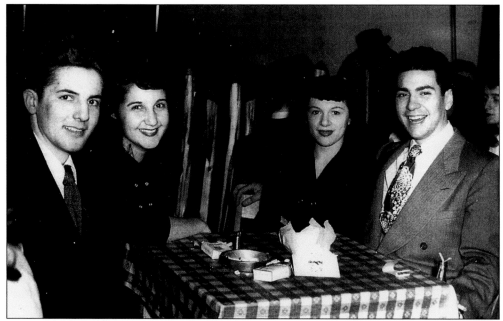

A 1948 picture shows four young people having a good time at the Barn. From left to right are Don Villa, Lucy Ciocchi, Betty Zeppetello, and Joe Montalbano. The Barn, home of the Gannett Youth Club, was built at the entrance to the Monroe County Fairgrounds. Donated by Frank and Caroline Gannett, it was dedicated on May 16, 1947. The Barn was a nightclub where a young couple could meet friends, have fun, and dance for just $2. Food and soft drinks could also be purchased. Buses would pick up students from the various city high schools, take them to the Barn, and come back later to take them home. *Life Magazine* did a special article on the Barn, "the first dry nightclub in the country."

# *Nine*

# FERTILE FARMS, FRIENDLY PEOPLE, AND THEIR HOMES

Farming was the main occupation in Henrietta from its earliest days, until the 1950s. Farms, both large and small, provided food for the family and beyond.

When the pioneers arrived in the early 1800s, times were difficult. The man in the family had to clear the land of deep forests, build some kind of shelter for the family to live in, hunt animals and fish for food, and eventually plant crops to live on during the winter months. Genesee fever and other diseases took the lives of both the young and the old.

By the mid-1850s, farming was well established and the farmers started to prosper. With the opening of the Erie Canal in 1825 and the railroads, farmers found markets both near and far for produce and grains. The early log cabins gave way to beautiful homes of cobblestones and prominent architecture. Because of the good soil, Henrietta had fertile farms. The land had acres of peas, corn, tomatoes, potatoes, oats, wheat, barley, and hay, and rolling hills that provided a wonderful landscape. There were also several dairy farms that supplied milk to residents in the area.

After World War II came the new demand for housing for returning servicemen. Much of Henrietta's farmland was sold for development. Residential and commercial areas were established in the northern part of town, leaving only the southern part still agricultural.

Even though Henrietta has lost many of its farmsteads and barns, those that are left remain productive and deserve much appreciation, as do the farms and farmers of old.

This beautiful, Greek-Revival home is the heart of the Smith-Yost farm at 208 Brooks Road. Built in 1830, it is a farm that the same family has worked for 100 years. In 2005, it was named a Centennial Farm by the Henrietta Historic Site Preservation Committee. Currently the owners grow hay and run a boarding operation for horses.

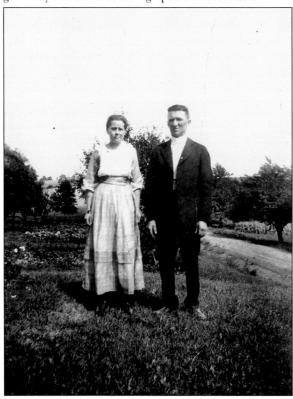

William and Martha Smith bought this farm in 1905. They are the grandparents of Henrietta resident Donald Yost.

Pictured on their wedding day are Laura Smith Yost and Irving Yost. Laura was the daughter of William and Martha Smith.

This is the living room of the Yost house about 1920. Laura Yost sits in a rocking chair enjoying a book.

The equipment shown in the photograph is a building saw, equivalent to the buzz saw of today. A workman stands nearby. Notice the Yost house in the background.

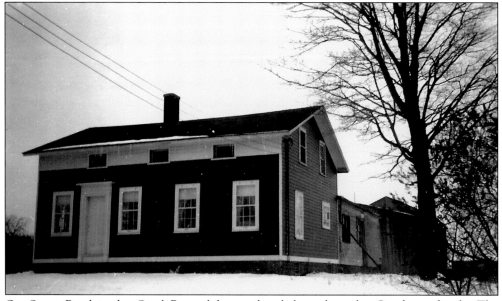

On Stone Road is the Greek-Revival home that belonged to the Goodman family. The Goodmans operated a farm there.

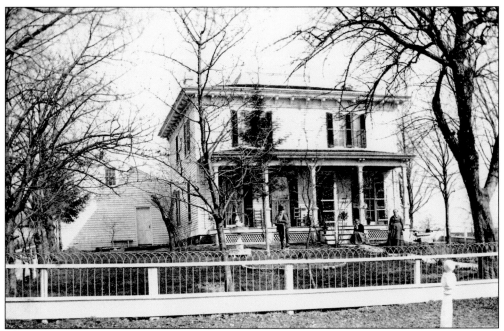

Harvey and Mary Ann Bundy Stone built this Italianate-style house at 3490 East Henrietta Road, about 1830–1840. Stone, who came to Henrietta in 1828, and his wife stand out front. Daughter Lucretia Belle sits on the steps of the porch. The house became a Winslow house when their daughter married into the Winslow family and then inherited the Stone house.

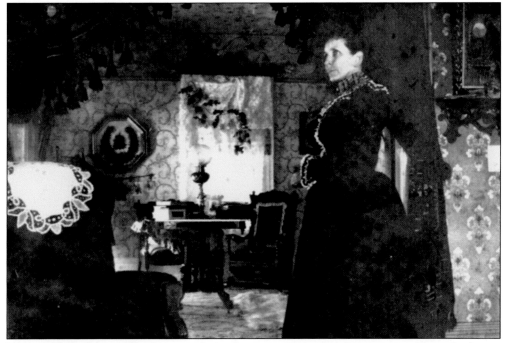

Lucretia Belle Stone Winslow stands in the entrance to her living room. Note the heavy velvet drapes and the Victorian atmosphere. Her home and outfit are very stylish, marking her as a trendsetter.

This wintry scene shows the Symonds farm at 248 Reeves Road right after a snowstorm.

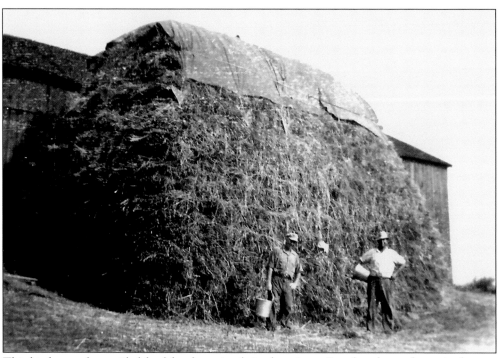

This big haystack provided food for the animals in the winter. Farmhands are shown in front.

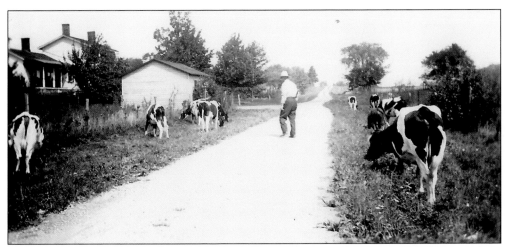

A hired hand tries to bring the cows in for milking. The animals seem to like the grass along the way.

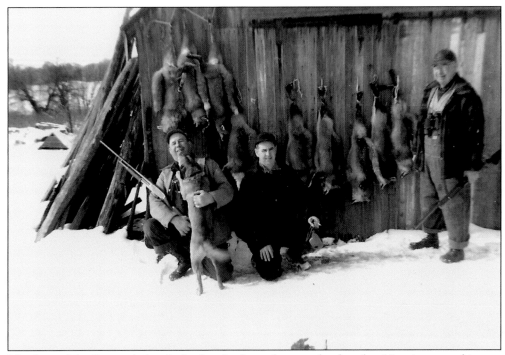

Members of the Symonds family display the foxes they caught that day. Hunting was a big part of farming life, especially in the early days. Oftentimes what the father killed during the day was what the family ate for supper that night. If the hunt produced nothing, the family might not eat at all.

This is John Boniface Vollmer as a young man on his trusty horse. The farmhouse on Clay Road is still standing.

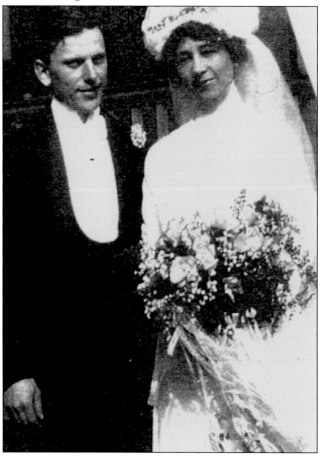

John and Abbie Vollmer are pictured on their wedding day, October 1, 1912. They were married for more than 50 years. Vollmer was a florist with his own store in Rochester. He also managed the parties and weddings of prominent families in the greater Rochester area.

Vollmer feeds the chickens on the farm with help from his son Jack.

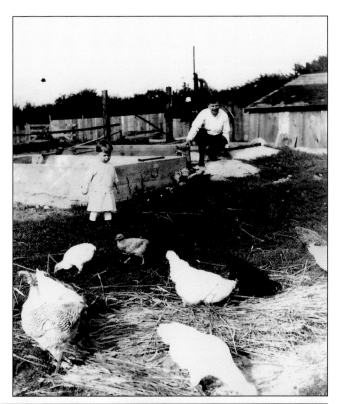

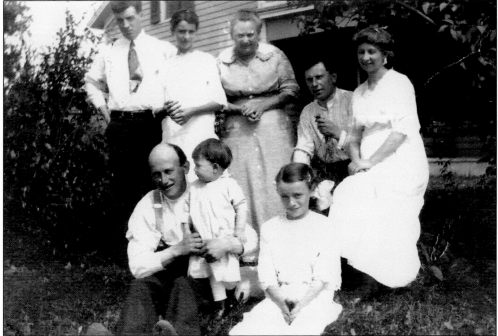

At a family gathering on the Vollmer farm are, from left to right, (first row) Lloyd Vollmer, young Jack Vollmer, and an unidentified girl; (second row) two unidentified people, Mary Hafley Vollmer, her son John, and his wife, Abbie Vollmer.

The Fishbecks lived in this house on Lehigh Station Road. They are an old Henrietta family.

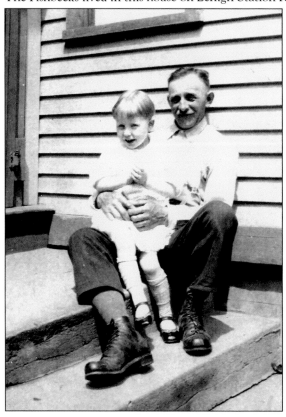

E. Gregory Fishbeck holds his granddaughter Alice in 1928.

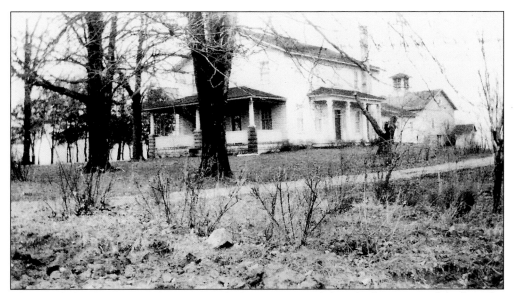

The Buyck farmhouse is still on 1420 Lehigh Station Road, but the barns are now gone. The Buyck farm was very large. The property started where the United Church of Christ is located and continued east along Lehigh Station Road for a half mile. The northern boundary was the Henrietta Memorial Park on Calkins Road. When the property was sold to developers, this farmhouse was turned into apartments. Descendants of the Buyck family still live in the area.

Here are three generations of Buycks.

Five Miller girls pose by a haystack. From left to right they are Mae Miller, Bertha Miller Buyck, young Inez Miller, Nellie Miller, and Grace Miller (seated).

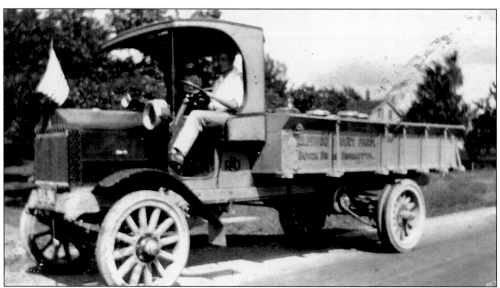

Shown is the Elmwood Dairy truck. The Elmwood Dairy was part of the Buyck farming operation.

Seen on their wedding day on July 31, 1935, are Margaret Wermuth and Casper Meisenzahl. Next to the groom is his father, also named Casper, and then Frank Wermuth. The girl in the picture is Carol Meisenzahl.

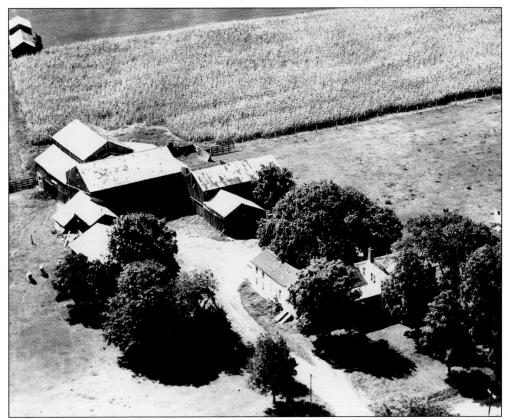

This aerial photograph shows the Clarence Smith farm on Bailey Road.

Clarence Smith poses on his motorcycle, which provided a good way to get about town.

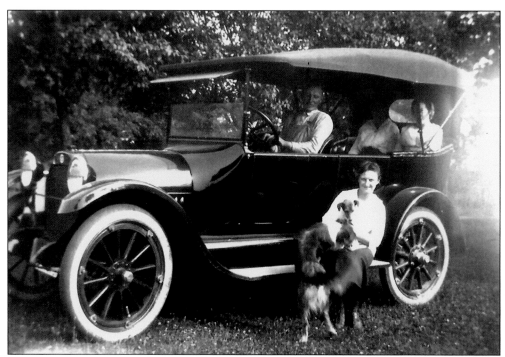

Smith sits in his new car with his wife Edna and a friend. Outside on the running board with the collie is Smith's sister Leora holding her dog Teddy.

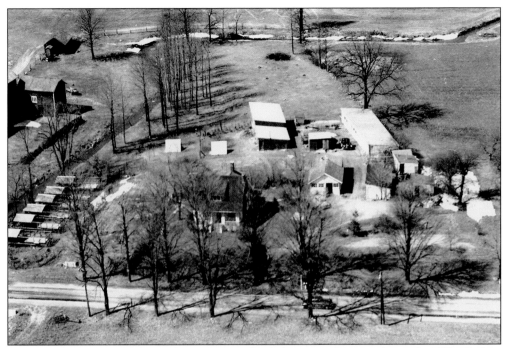

This aerial photograph shows the Robert and Ethel Martin farm in the early 1950s. Robert Martin was one of the trustees of the Henrietta Masonic Lodge, which met in the Corner Store building on West Henrietta Road.

The farmhouse at 5567 East River Road was the home of Pryor F. Martin. Martin was the great-great-grandfather of Rusty Martin, the town highway superintendent. Many of the Martin families in Henrietta are descended from the town's early pioneers. Members of one family who lived in a large farmhouse on Martin Road had the road named for them.

Shown is the Elijah Webster family home on Edgewood Avenue.

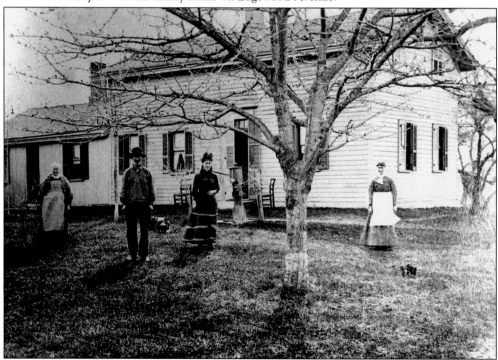

A Smith farm was located at 649 Pinnacle Road. Grandma and Grandpa Smith are on the left, and Margaret Smith and Mary Jane Smith are on the right in this picture, which was taken in 1880.

Children of the Vollmer family gather in 1894 to greet their father, John Vollmer, who is on his wagon led by a team of horses. The youngest son, Albert Vollmer, stands behind the wagon and son Leander stands to the right of it. The mother is Katherine Vollmer, daughter Lillian and a neighbor girl stand next to her.

The Trout Spring Farm House, at 1330 Calkins Road, is an early-built home with a kitchen that dates from 1805. The house was built by the Robertson family around 1823, and the farm included 150 acres. As was often the case with the early pioneers, the Robertsons built a one-room house with a basement that included a fireplace and a beehive oven, plus sleeping quarters in a loft upstairs. When they were more successful, they added rooms to the house. Only three families have owned the Trout Spring Farm House, which today has six fireplaces and much of its original hardware. Its name comes from a stream running through the property, which had trout in it that literally leapt from the water. A tract of homes nearby bears the same name.

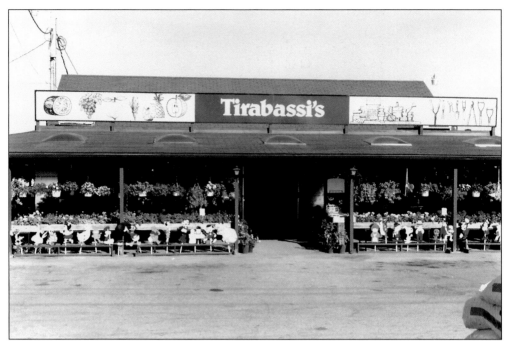

The Tirabassi Farm Market, at 5575 West Henrietta Road, was a popular place to buy farm produce and obtain garden supplies. Pictured in 1994, the market was run by John Tirabassi, son of Emidio Tirabassi, who came from Italy and settled on Middle Road in 1917. The father bought the brick home next door, where the Tirabassi children were raised. The market and farm were sold to Konar Properties in the late 1990s.

A vegetable crop is growing in the field behind the Tirabassi Farm Market, as seen from Erie Station Road in 1994.

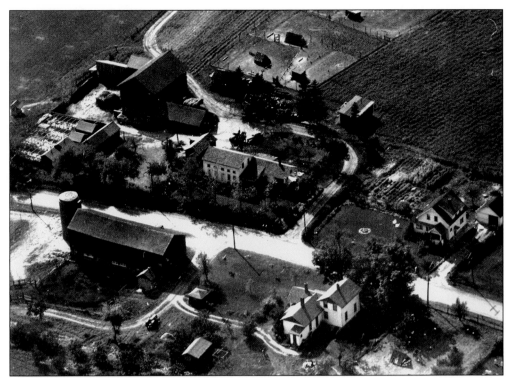

A close inspection of this picture reveals some turkeys at the farm on Hirschman's Hill on East River Road. It is a big farm, and the road on the top leads right back to the river.

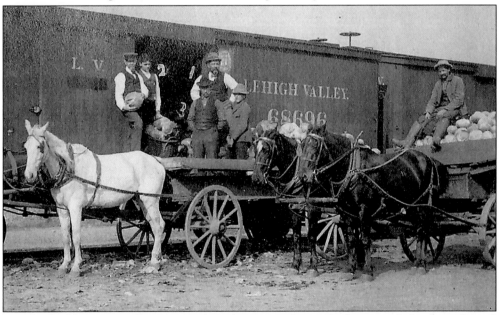

Men load cabbages onto the train, sending them to market in Rochester and elsewhere. Samuel Calkins and his son John were in the produce and coal business (produce in the summer and coal deliveries in the winter). They began this operation in the mid-1880s. When the father retired, the son took over the business and brought into it his son Richard, who is now in his 90s.

Members of the Chase family stand in the front yard of their homestead. The house remained on Castle Road (formerly Chase Road) until it was torn down to make way for new housing. Descendants of the Chase family have remained in Henrietta, and many have held prominent places in town government and the community.

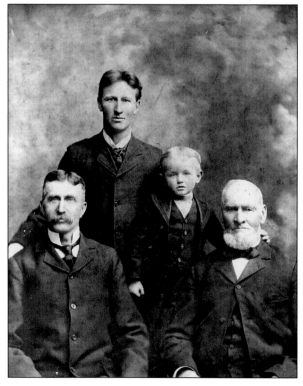

Pictured are four generations of the Chase family. From left to right they are Willet Chase (1844–1910), his son Frank Chase (1872–1916), his grandson little Earl Chase (1896–1980), and his father Daniel Chase (1815–1888).

The residence of Milton Brooks is still standing, although slightly altered. Some of the other buildings, however, remain unchanged. A small train still goes through Brooks Road at least once a day. The road was named after Brooks.

This lovely house has a serene setting, especially in winter. It was built by C. E. Ladd, an early pioneer, on 155 Reeves Road.

The Brown home stands on 1099 Pinnacle Road. Uncovered on a surround of the fireplace was a date of 1797, which seems early for buildings in Henrietta.

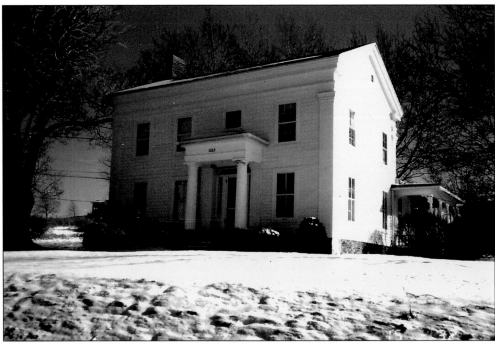

This Greek-Revival house stands on the southwest corner of Erie Station Road and Middle Road and was built by Wesley Search, from an early pioneer family. The tall hill it is situated on became known as Search Hill. It overlooks a grand view of the city of Rochester.

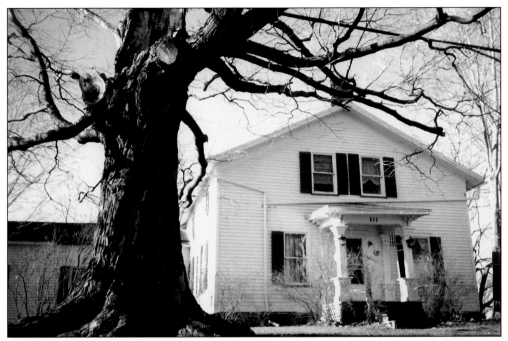

Mr. Claire Ladd lives in an ancestral home on Telephone Road in Henrietta. Several Ladd families were early residents of the town, and they built homes on various roads in Henrietta. Claire Ladd's son Todd manages the farm and lives in the tenant house on the property.

The Van Voorhis family farm is still in operation after nearly 100 years. A large farm, it is located on Williams Road.

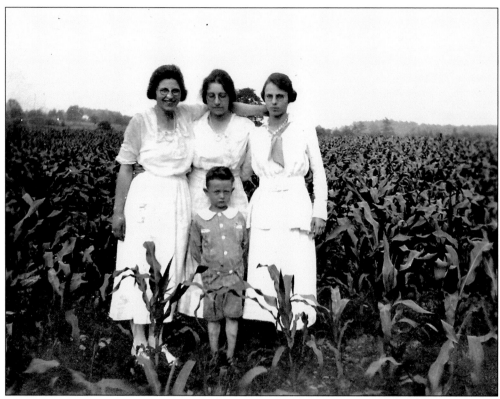

These four young people in the cornfield are members of the Ubelacker family of East River Road.

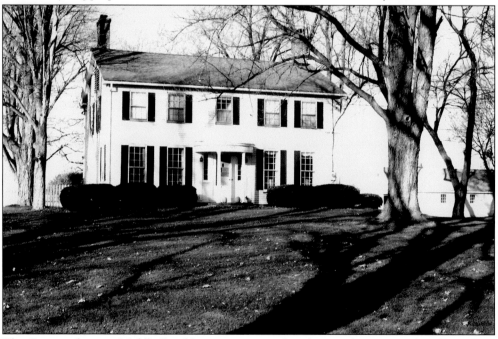

The Gannett farm on Middle Road became an agricultural research project. Many Farm Days were held in its huge barns. The John Buyck family lived there for many years.

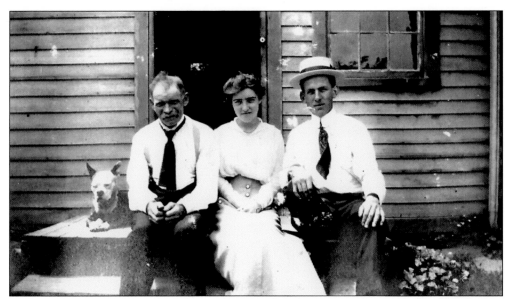

In this 1918 scene, John Halpin Sr., in the straw hat, has come courting Esther Schafer. Her father, Theodore Schafer, keeps a watchful eye on the young couple, who eventually married and spent many happy years together. The Schafer farm was located at 1294 Lehigh Station Road. The house is still standing.

This local historian, Ethel Calkins, became the wife of John Calkins and mother to Richard Calkins of Lehigh Station Road. The town is grateful for the notes she kept on the events of the town while she was alive. Through her, it is known that electricity came to Henrietta in 1922. She and other historians are essential, because they save the story of their area for later generations to read and enjoy.

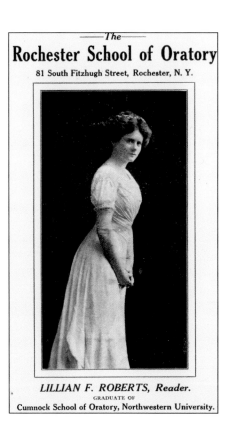
Lillian F. Roberts is pictured in this advertisement. She often appeared in musical and oratorical performances in Henrietta and Rochester. In 1917, she became the wife of Albert R. Jones. Oratory was offered at various educational facilities and was quite popular in its day, and by the early 1900s, musicals were being performed in West Henrietta.

Well Kern was a blacksmith by trade. He worked in West Henrietta, north Rush, and in Rochester.

Mary Ann Bundy Stone was a temperance leader in Henrietta. She is shown here wearing her temperance pin.

Emma Sherman was a noted West Henrietta resident. She was a schoolteacher who devoted her life to teaching schools in Henrietta. An elementary school was named for her and was dedicated on November 10, 1966. It is located on Authors Avenue.

Born in 1846 in Pennsylvania, Isaac Jones, a Quaker, became the stationmaster when the Rochester and Genesee Valley Railroad built a new line in West Henrietta that was eventually called the Erie Railroad.

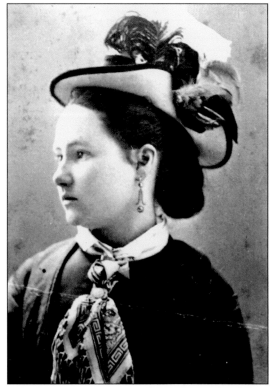

Julia Gregory married Jones, who worked as a stationmaster on the Erie Railroad.

Sara Willard Fenner graduated from Geneseo State Teachers College in 1906.

Joan Vollmer Beebee grew up on her father's farm on Clay Road. She is pictured around 1945 in a traditional cap and gown, at the time of her graduation from first grade at St. Boniface School in Rochester.

In this 1930s picture, from left to right, are (first row) Frances Chamberlain, Jeanette Buyck, and Phyllis Buyck McHargue; (second row) Petie Chamberlain, Bertha Buyck, and Aziel "Pete" Buyck.

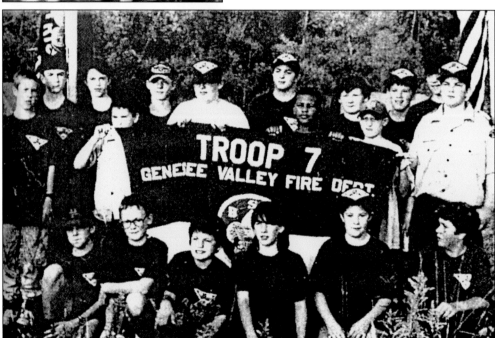

Boy Scout Troop No. 7 has seen many of Henrietta's young boys go through its programs. The troop celebrated its 50th year in 1998. The scouts deserve congratulations, and the scout leaders deserve many thanks for their successful guidance.

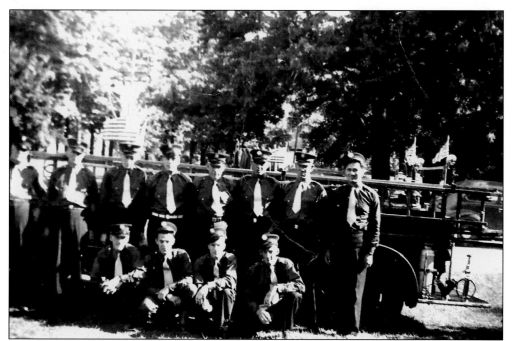

Pictured are firefighters of the Henrietta Fire District No. 1 on East Henrietta Road. These brave volunteers stand ready to save homes and businesses from fire and trouble. Their tireless work deserves full gratitude and should never be forgotten.

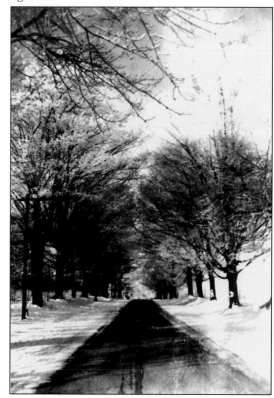

Traveling down memory lane is an exciting adventure. For a change of pace, imagine a slow ride in a horse and buggy down Lehigh Station Road, near Sperry Drive where this picture was taken. This quiet road has just one lane, no traffic, and no hassle—very relaxing.

# DISCOVER THOUSANDS OF LOCAL HISTORY BOOKS
## FEATURING MILLIONS OF VINTAGE IMAGES

Arcadia Publishing, the leading local history publisher in the United States, is committed to making history accessible and meaningful through publishing books that celebrate and preserve the heritage of America's people and places.

### Find more books like this at
### www.arcadiapublishing.com

Search for your hometown history, your old stomping grounds, and even your favorite sports team.

Consistent with our mission to preserve history on a local level, this book was printed in South Carolina on American-made paper and manufactured entirely in the United States. Products carrying the accredited Forest Stewardship Council (FSC) label are printed on 100 percent FSC-certified paper.

MADE IN THE
USA